FEATURES
AND FACES

GEORGE B. BRIDGMAN

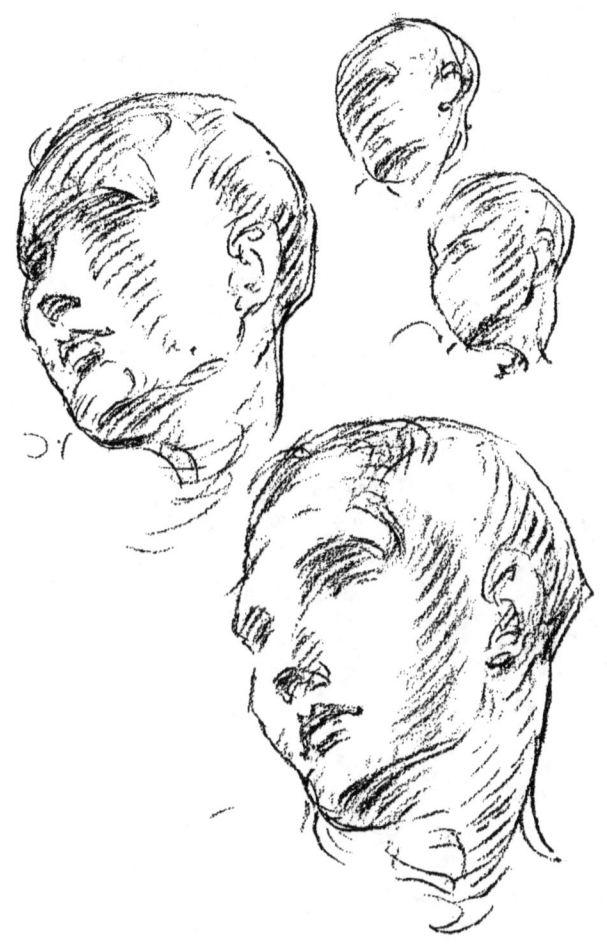

Features *and* Faces

GREEN
POINT
BOOKS

For information, address:
Angelico Press, Ltd.
169 Monitor St.
Brooklyn, NY 11222
www.angelicopress.com

Pb: 979-8-88677-102-2
Cloth: 979-8-88677-103-9

Cover design
by Michael Schrauzer

FOREWORD

Many are giving attention to Art today, who would be glad of some knowledge if presented with sufficient clearness and simplicity to make clear and comprehensive the analysis of details to the mass and outline as a whole of any object.

This book of Features and Faces has been built around a dozen drawings originally intended to be published in portfolio form. The drawings on pages 27, 29, 31, 33, 35, 37, 39, 40, 43, 45, 47 and 49, are the original twelve drawings.

It is planned that if there is enough demand for these pages it will be arranged to print these units in sheet form for classroom use. Comment upon the desirability of releasing these twelve sheets in this form will be appreciated.

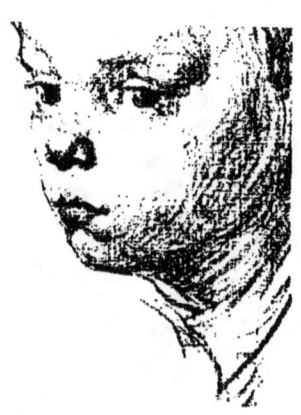

TO ELEANOR

TABLE OF CONTENTS

BEGINNING A DRAWING

Place carefully the outline only of the mass first on the paper or canvas. Arrange your area so that there is correct balance of space, keeping in mind these areas are not too crowded or too empty. Make your outline first in long, straight lines.

If you are drawing a head and the neck, draw them in at the same time, merely indicating the features. Work out the perspective, then check up. Try to make the sides recede or come forward as you sense them. Afterwards work out the problems of the planes.

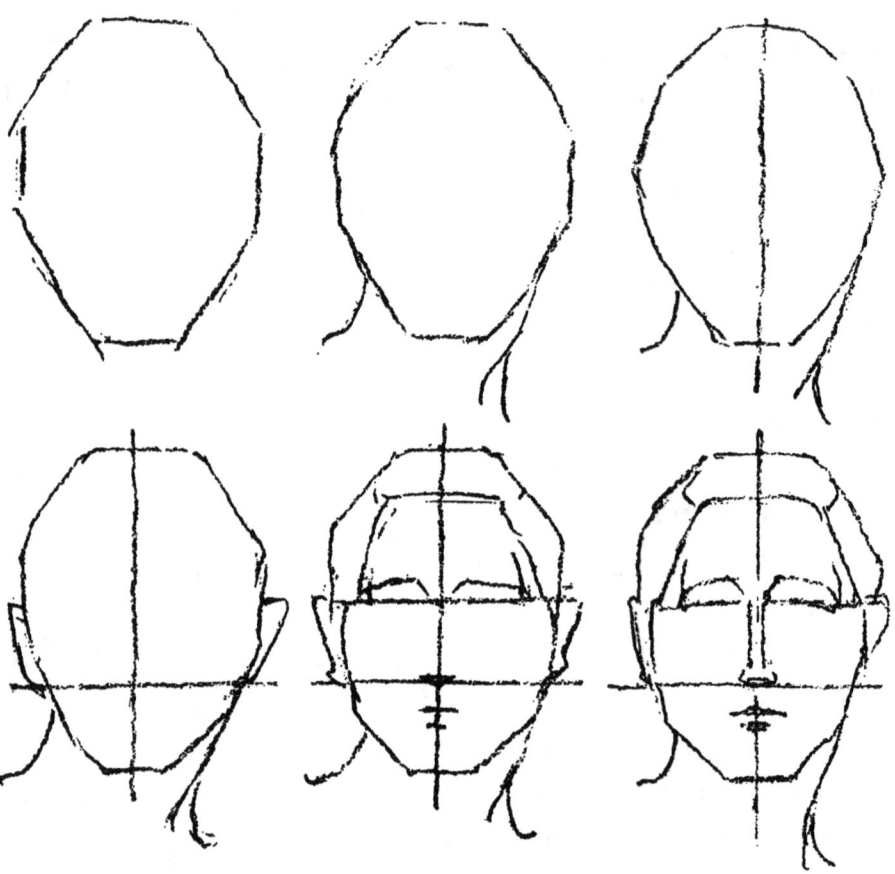

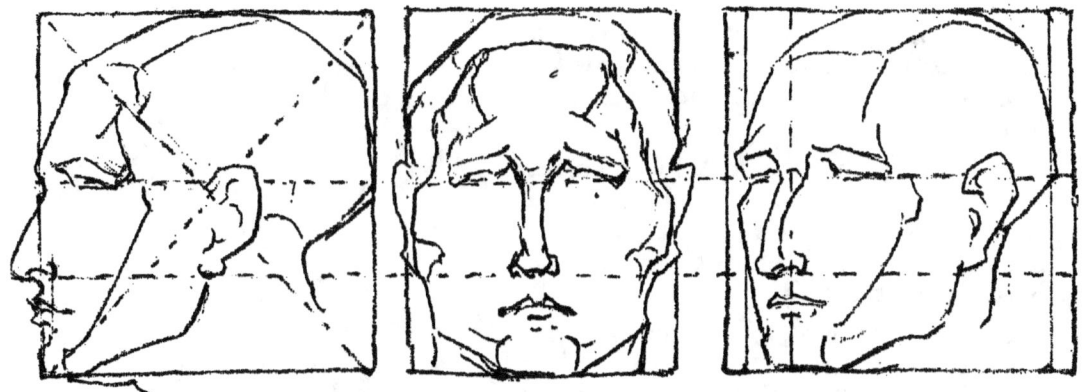

THE HEAD AT EYE LEVEL

Assume a profile view of a head measures eight by eight inches. Directly in front or from the back, the relative proportions would be six by eight. At three-quarters view it would be somewhere between the two measurements.

First draw with straight lines the general outline of the head. Draw a straight line through the length of this face, passing through the root of the nose, which is between the eyes, and through the base of the nose where the nose centers in the upper lip. Draw another line from the base of the ear at a right angle to the one just drawn.

On the line passing through the center of the face, measure off the position of the eyes, mouth and chin. A line through these will parallel the line that has been drawn from ear to ear at a level with the nose. With straight lines draw the boundaries of the forehead, its top and sides, and the upper border of the eye sockets. Then draw a line from each cheek-bone to the widest part to the chin on the corresponding side at its highest and widest part.

If the head is on the level with your eyes, the lines just drawn will intersect at right angles at the base of the nose. If both ears are visible and the line from the ear extended across the head, it will touch the base of the nose. If the head be above eye level or tilted backwards, the base of the nose will be above this line from ear to ear. Should the head be below eye level or tilted forward, the base of the nose will be below the line from ear to ear. In either case the head will be foreshortened either upward or downward.

PLANES

Heads in general should be neither too round nor too square. All heads, round or oval or square, would be without contrast in form.

In drawing, one must look for or suspect that there is more than is casually seen. The only difference in drawing is what you sense, not what you see. There is other than that which lies on the surface.

Planes are the front, top or sides of a mass. The front of a face is the front plane. The ear side is another plane. Spectacles are hinged to conform to the front and sides of a face.

The square or triangular forehead must have a front and two sides, making three planes.

The face turns at a line from each cheek-bone downward to the outer side of the chin. There is also a triangular plane on each side of the nose, its base from tip to wings forms another triangular plane. There is also the square or rounded chin with planes running back from each side.

Border lines separate the front and sides of the forehead above, and cheek-bones and chin below. Across from ear to cheek-bone is a ridge separating two more planes which slope upward toward the forehead and downward to the chin.

Considering the masses of the head, the thought of the masses come first, then the planes; after that the rounded parts of the head. There are four rounded forms on the skull. One on the forehead, two on the sides of the head, just above each ear, and one on the front of the face, extending from nose to chin. On each side, at the upper part of the forehead are two rounded elevations termed the frontal eminences. These eminences often merge into one and are referred to as the frontal eminence.

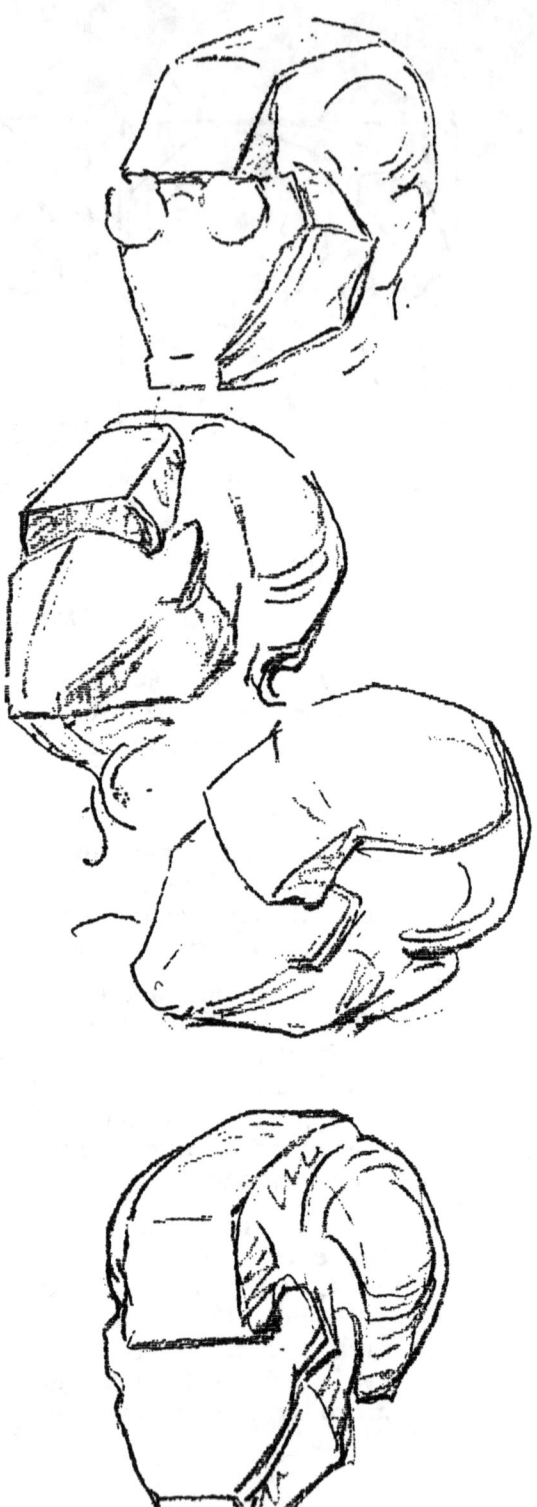

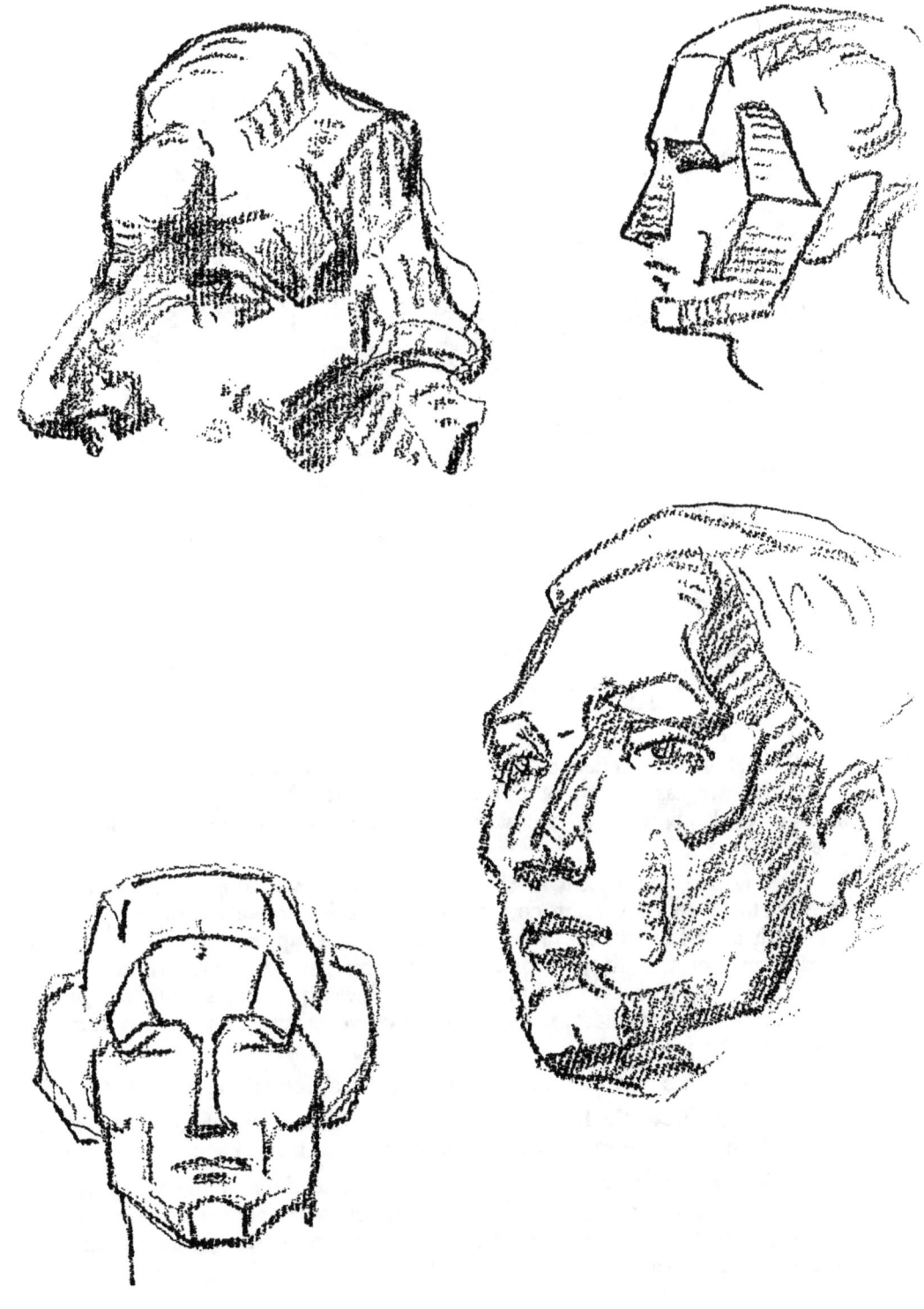

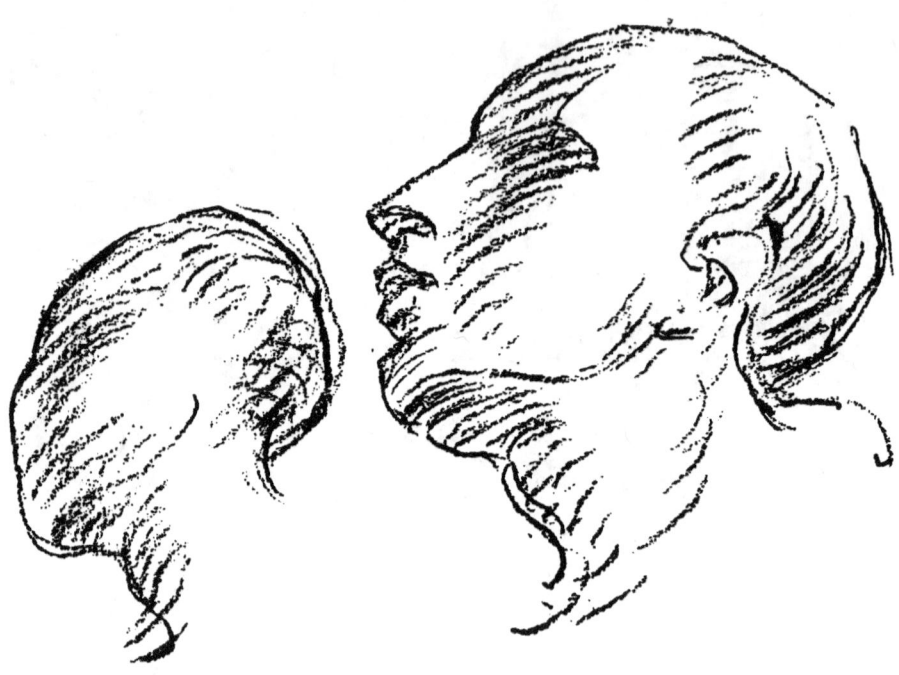

THE HEAD - ROUND FORMS

The skull is rounded on both sides of the head directly on a line above the two ears. Part of this formation is the Parietal bone; a thick spongy shock absorber at the side of the head, at its widest and most exposed portion.

Below this, cylindrical in shape, comes the rounded portion of the face. This rounded portion corresponds to the lower portion of the face inasmuch as it has front and receding sides. The upper portion, known as the superior maxillary, is irregular in shape and descends from the base of the eye socket to the mouth. The lower portion, known as the lower or inferior maxillary, takes the same curve as the mouth and is part of the angular jaw bone.

The nose lies on the center of this cylindrical formation.

Below the nose, the lips follow the contour of this part of the rounded form, which as a covering, takes the shape of the teeth.

It is in reality, plane against plane, adjusted at different angles, which forms the shape of the head. There is no exact mathematical proportion, but in perspective or from any angle, we are forced to truly balance one side with the other.

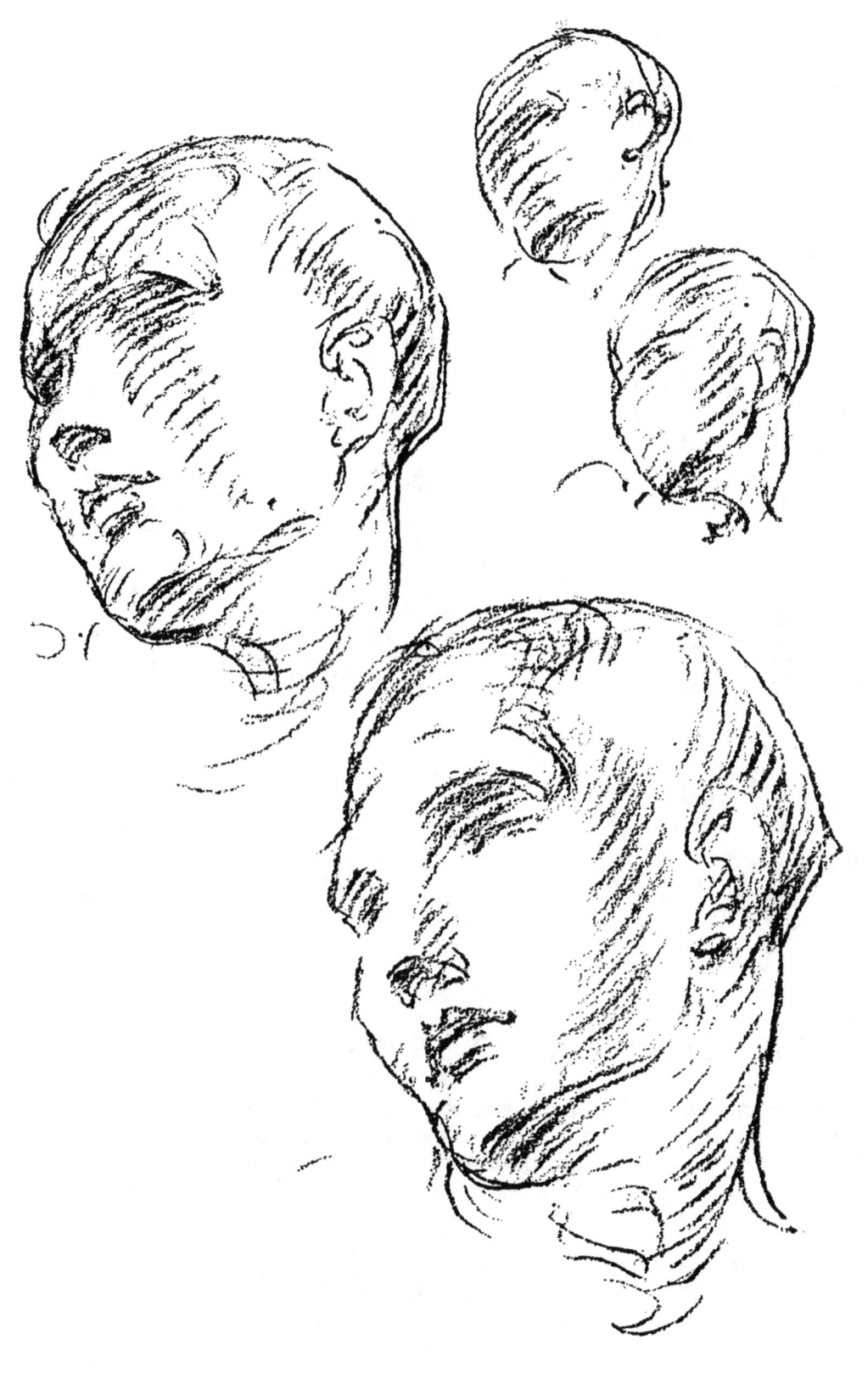

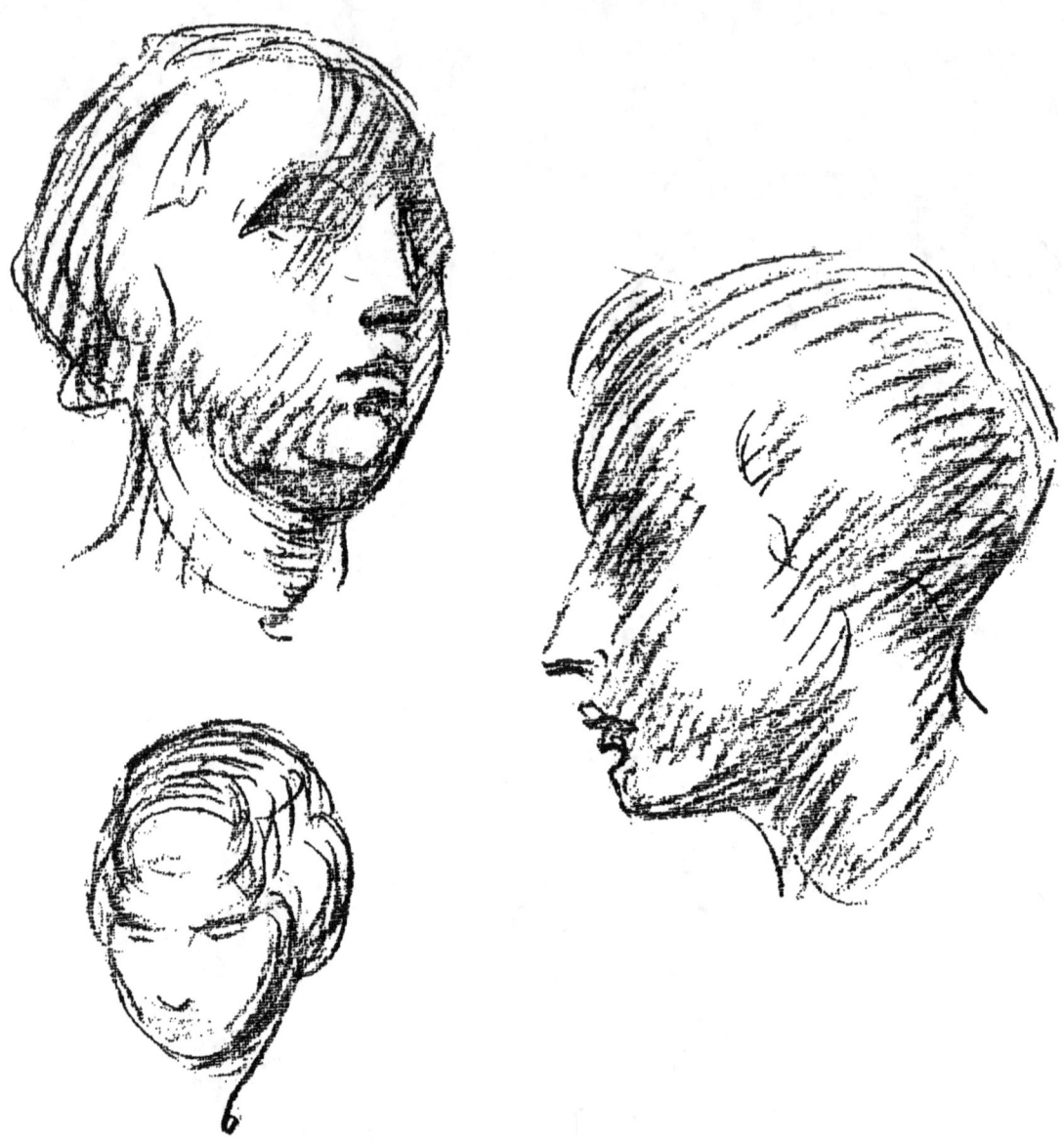

THE HEAD ROUND AND SQUARE FORMS

A square line naturally is the outline of a square form. A round line is the outline of a round form. The classic beauty of all drawing is a happy combination or contrast of both these forms. A partially rounded square form or a partially square rounded form adjacent to each other do not produce power or style.

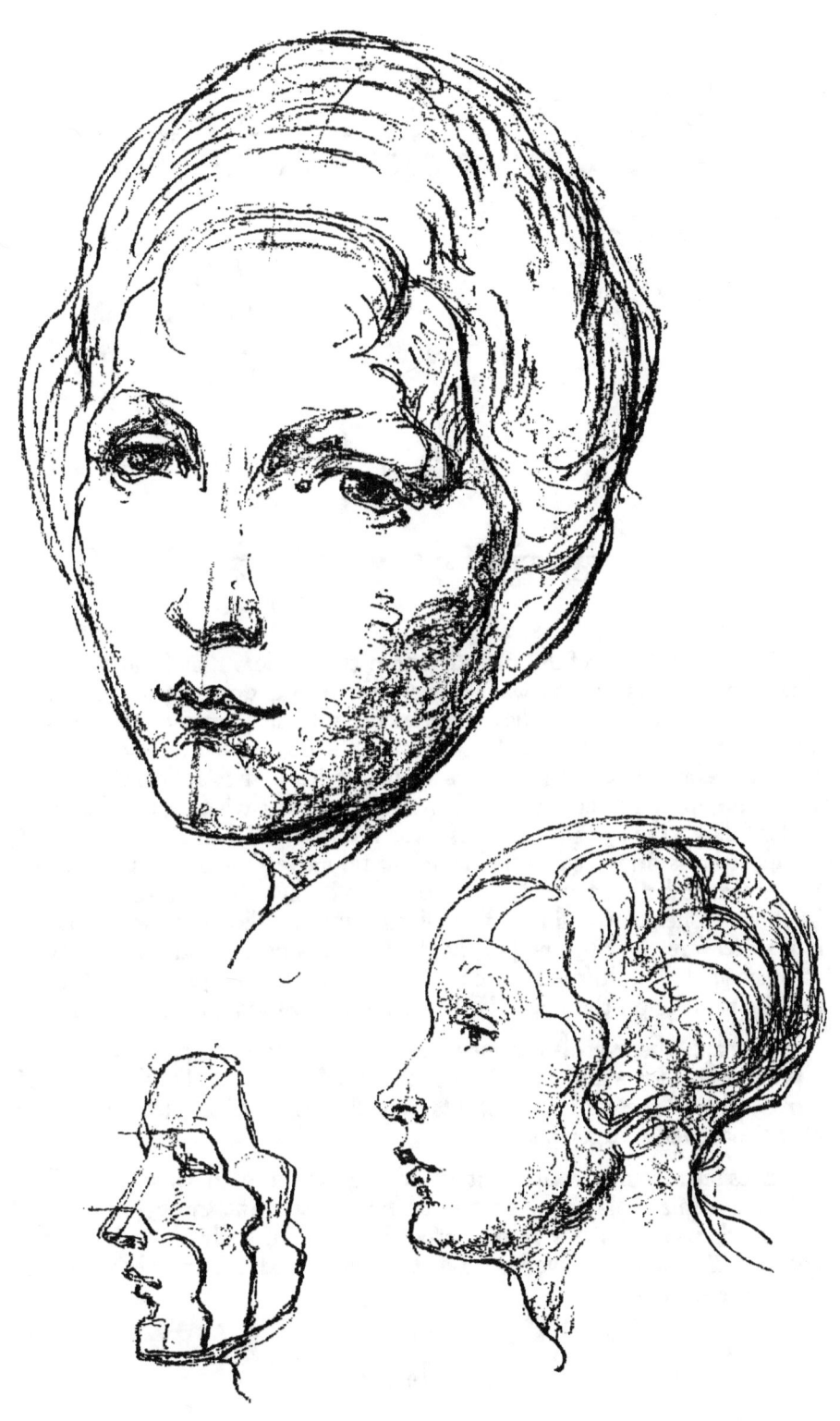

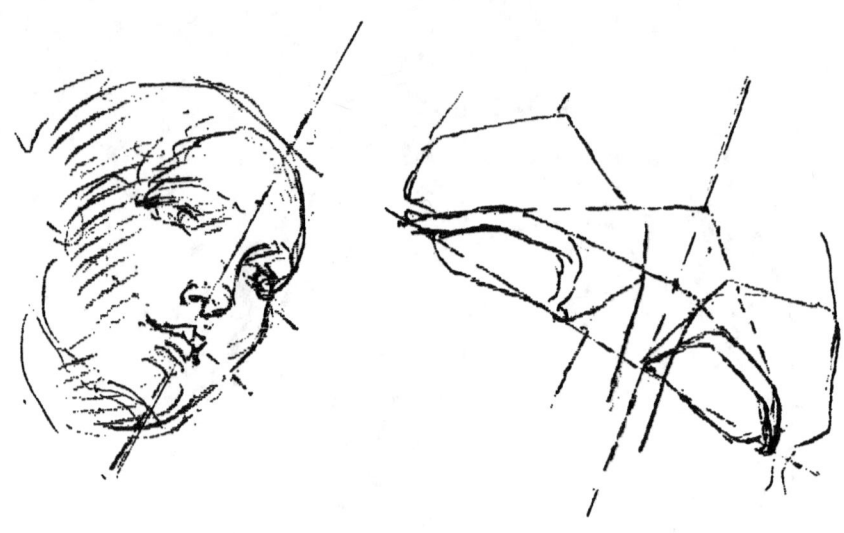

FEATURES - THE EYE

Eyes must be carefully placed within the borders that form the walls of the eye sockets. These walls slope inward and downward from forehead to cheek-bone. From these cavities the spherical form of the eye ball presses outward following at the same time the downward slope of the cavity. The eyebrows mark the borders of the forehead, they follow the frontal bone. The upper lid moves over the curved eye ball when open, the outer border follows the eye back, folding in as it does so. When the eye is closed the upper lid is drawn smooth. The lower lid moves but little. It is stationary enough to be used as a line for measuring when drawing the head. At the inner corner of the lids is a small pinkish pit called the inner canthus near which are the openings of the tear ducts which drain off the excess lacrymal fluid. The transparent cornea, or, apple of the eye, is raised, making a light bulge on the upper lid in whatever position the eye moves.

In shape, the eyeball is somewhat round. Its exposed position consists of pupil, iris, cornea and the white of the eye. The eye is slightly projected in front, due to the cornea which fits over the iris, making a part of a small sphere laid over a larger one.

Eyes seen from directly front are equally balanced. A view from three-quarters will also balance perspectively. First pass a line through the lower eye lids, then draw a line from the outer border of each upper lid to the central facial line. As eyelids have two sides and a front, balance the front in the same way.

[14]

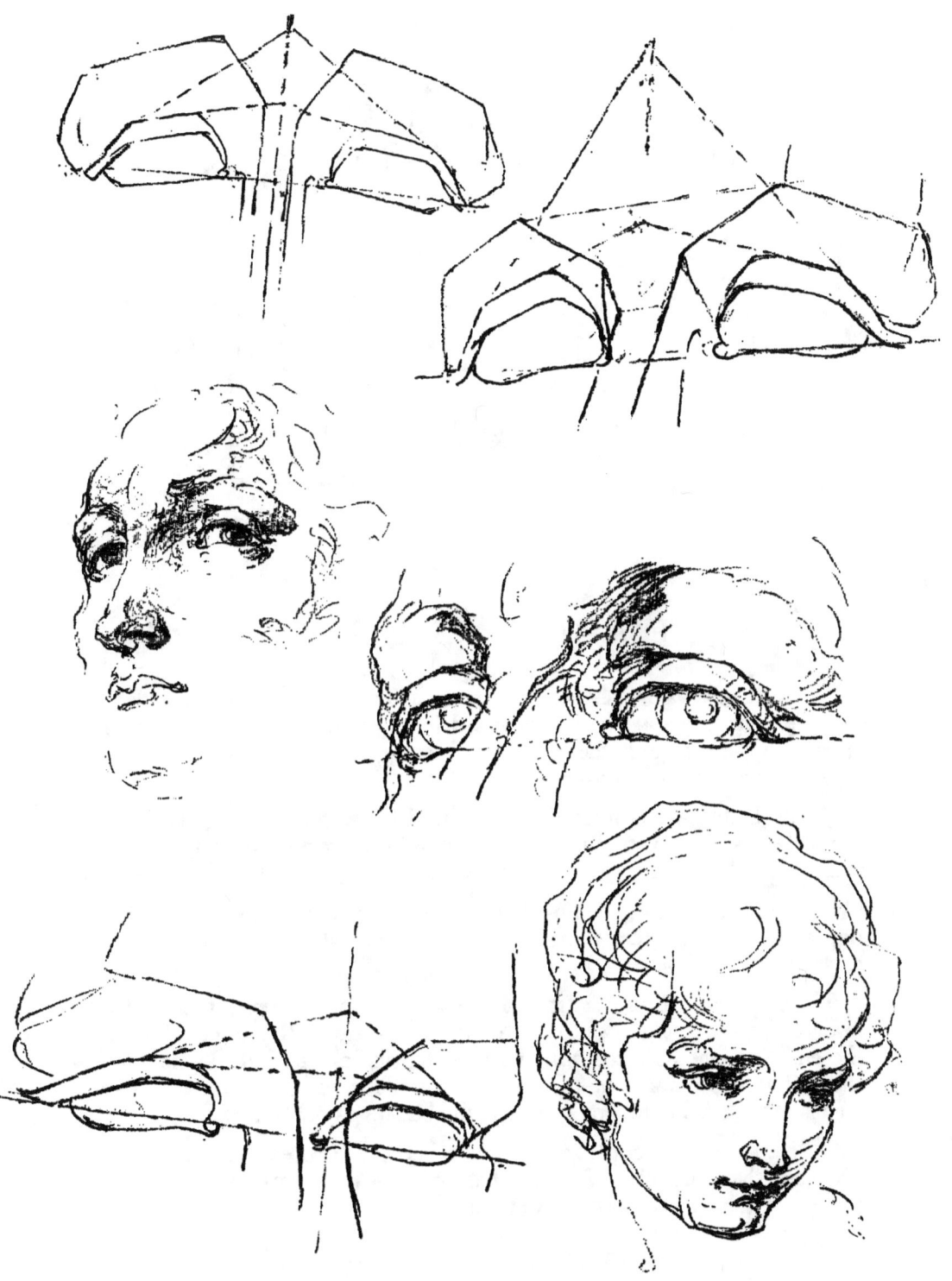

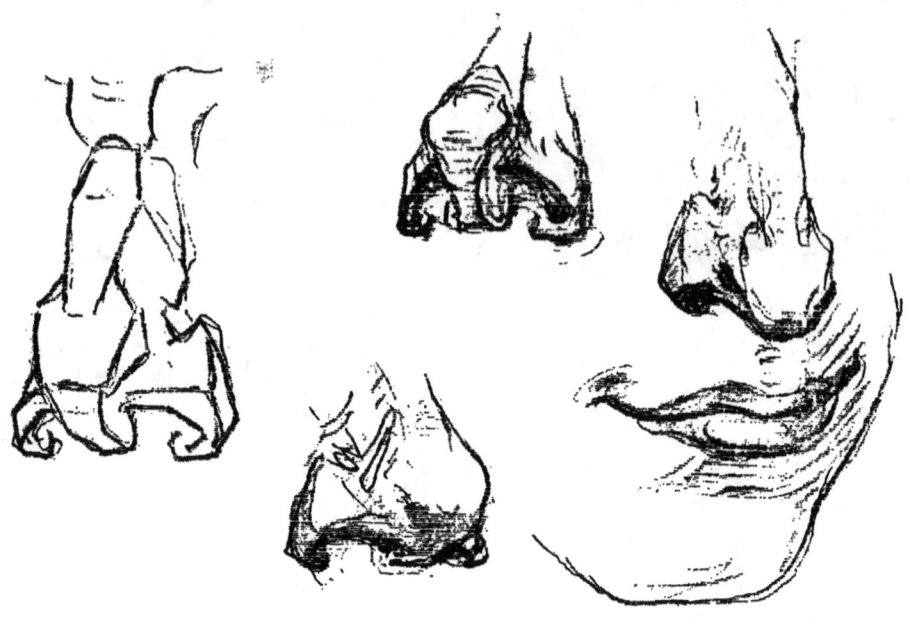

FEATURES - THE NOSE

The nose is wedge shaped, narrow at its upper extremity and wide at its base. The upper portion is mortised into the forehead, its base corresponds to the centre of the upper lip. The upper part reaches about half way down and consists of bone.

The bony part is formed of two nasal bones which are rooted into the glabella of the frontal bone. Descending, they form the bridge of the nose.

The lower part of the nose is composed of cartilages, five in all. Two upper, two lower laterals and one, the septum, which divides the nasal cavities.

There are planes on the front and both sides of the bony part of the bridge. There are two sides to the fullness of the tip, with another plane at the end that embraces the wing part of the tip and the buttress between them. The outer walls of the cavities are called wings. They are more angular than round and are known as the buttresses of the nose.

Planes are the front, top and sides of masses. A nose has a front, top and sides, therefore, planes. As the shape of these masses vary considerably, the exact shape of the planes are arbitrary.

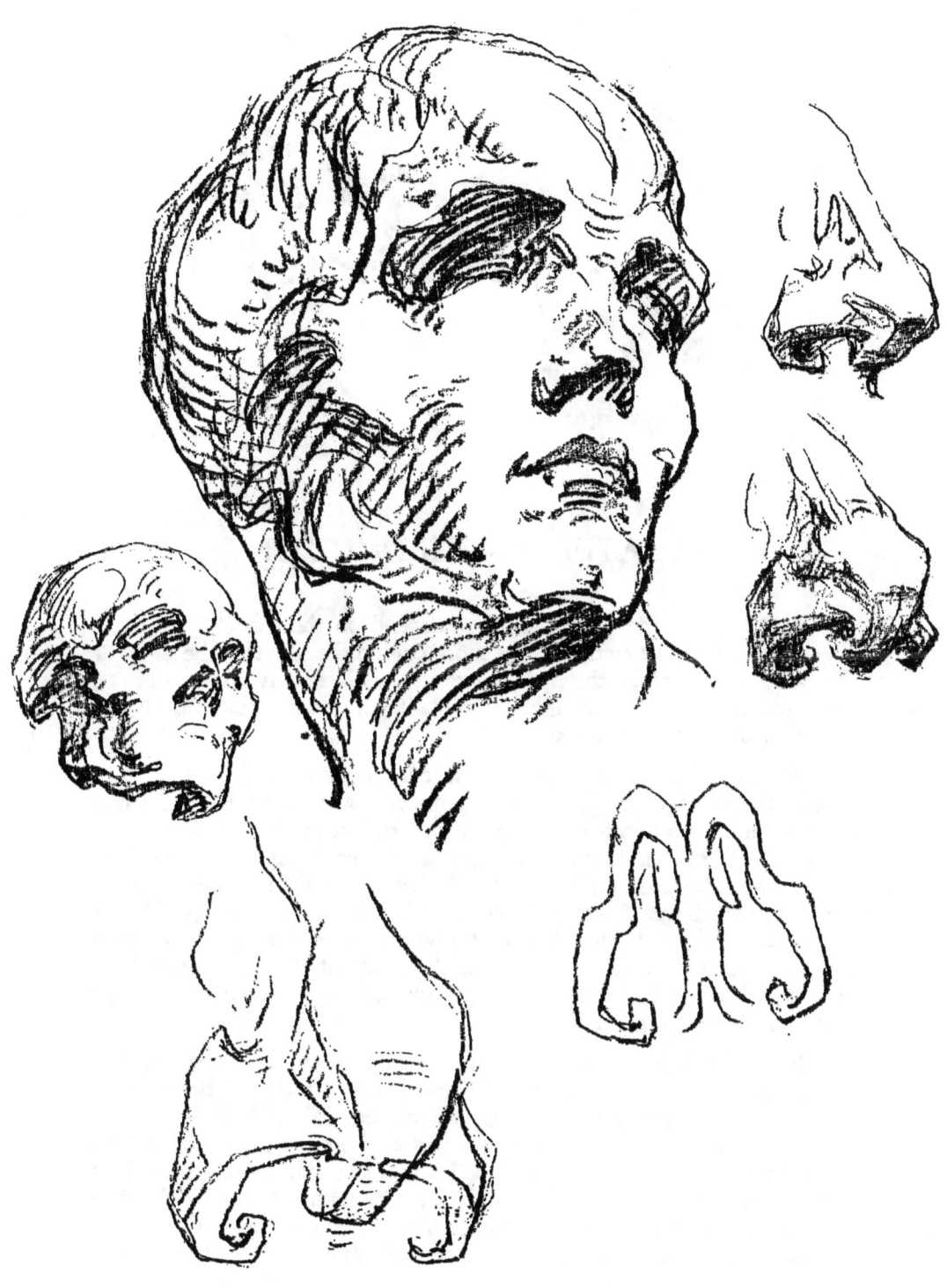

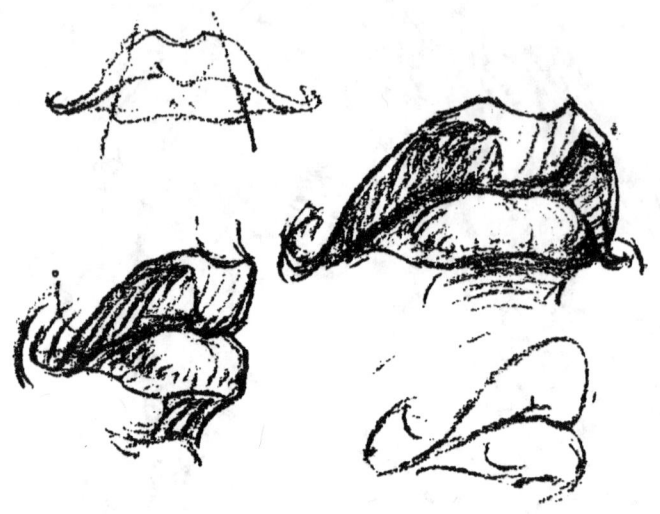

FEATURES - THE MOUTH

The shape of the mouth and lips depend on the shape of the teeth. The more curved the teeth are, the more curved the mouth. The more flat they are, the straighter the lips. A mouth that is acutely curved does not occur on teeth that are straight in front, nor a straight thin mouth on a curved cylindrical set of teeth.

From the base of the nose to the curtainous or red portion of the mouth is the upper lip. The upper lip presents a groove which blends on each side into two broad drooping wings terminating at the pillars which marks the end of the mouth. The upper and lower red lips, yet quite different in form, fit accurately when closed. The upper lip is more angular in shape than the lower lip. It is composed of a body and two wings. The center is wedge shaped, indented at the top where the two long slender wings interlock and curve to disappear under the pillars of the mouth. The lower lip has a groove and a lateral lobe on either side which diminishes in thickness as they curve outward.

In profile there is a series of steps from nose to chin. The upper lip overhanging the lower, the lower lip overhangs the chin. The upper lip presents but half a wedge, the wing twisting upon itself locks the wedge-shaped body above, then curves downward to the mouth. The lower lip in profile starts at the central groove, the lateral lobes diminishing in thickness as they curve outward. The oval cavity of the mouth is surrounded by a circular muscle (the Orbicularis oris), whose fibres overlap at the corners. The twisting and the turning of these fibres form the pillars of the mouth.

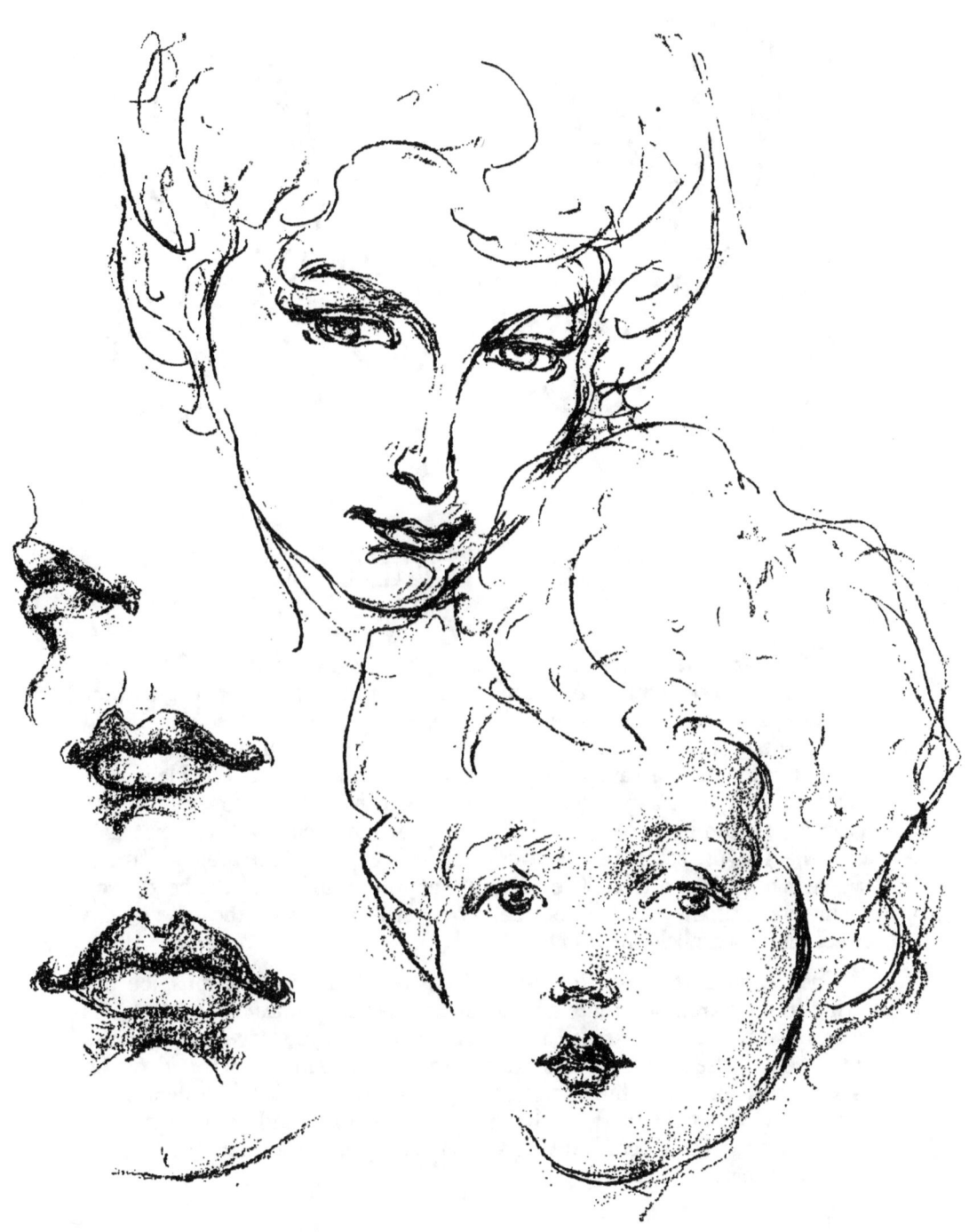

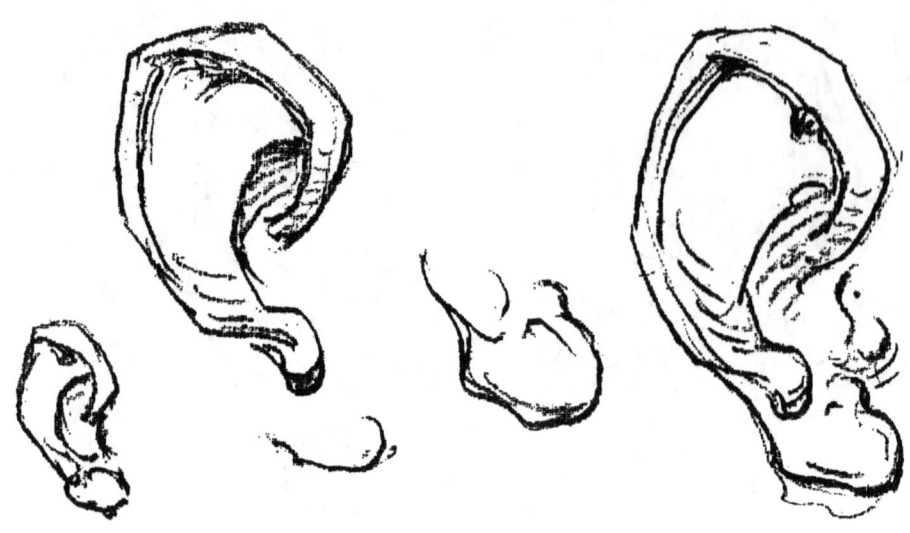

FEATURES - THE EAR

The ear is vertically on a line with the receding portion of the jaw-bone and lies horizontally between the lines of the brow and the base of the nose. The ear is shaped like half of a bowl with a rim turned out. Below is appended a piece of fatty tissue called the lobe. The greater part of the ear is formed of one cartilage. The outer rim is known as the Helix, the inner portion the Anti-Helix, in front of which is the hollow of the ear (Concha), leading to the canal or inner ear. In front of this point is a flap, the Tragus, behind and below a smaller one, the Anti-Tragus. To the whole is appended a lobe. The ear is about in the middle of the head, seen from direct profile the lobe of the ear is on a level with the base of the nose, the tip parallels the brows.

Knowledge is the result of effort and study. The student must be un-tiring in his search of minute details, making pencil studies of parts such as eyes, nose, mouth and ears, so as to gain a detailed knowledge that becomes intimate and deep. It is by this knowledge that a foundation is laid which is solid and sure; it is by this knowledge that he is enabled to depict the more characteristic forms, to eliminate non-essentials and unnecessary de-tails. Knowing these details intimately one can give the appropriate balance of parts to eliminate and simplify.

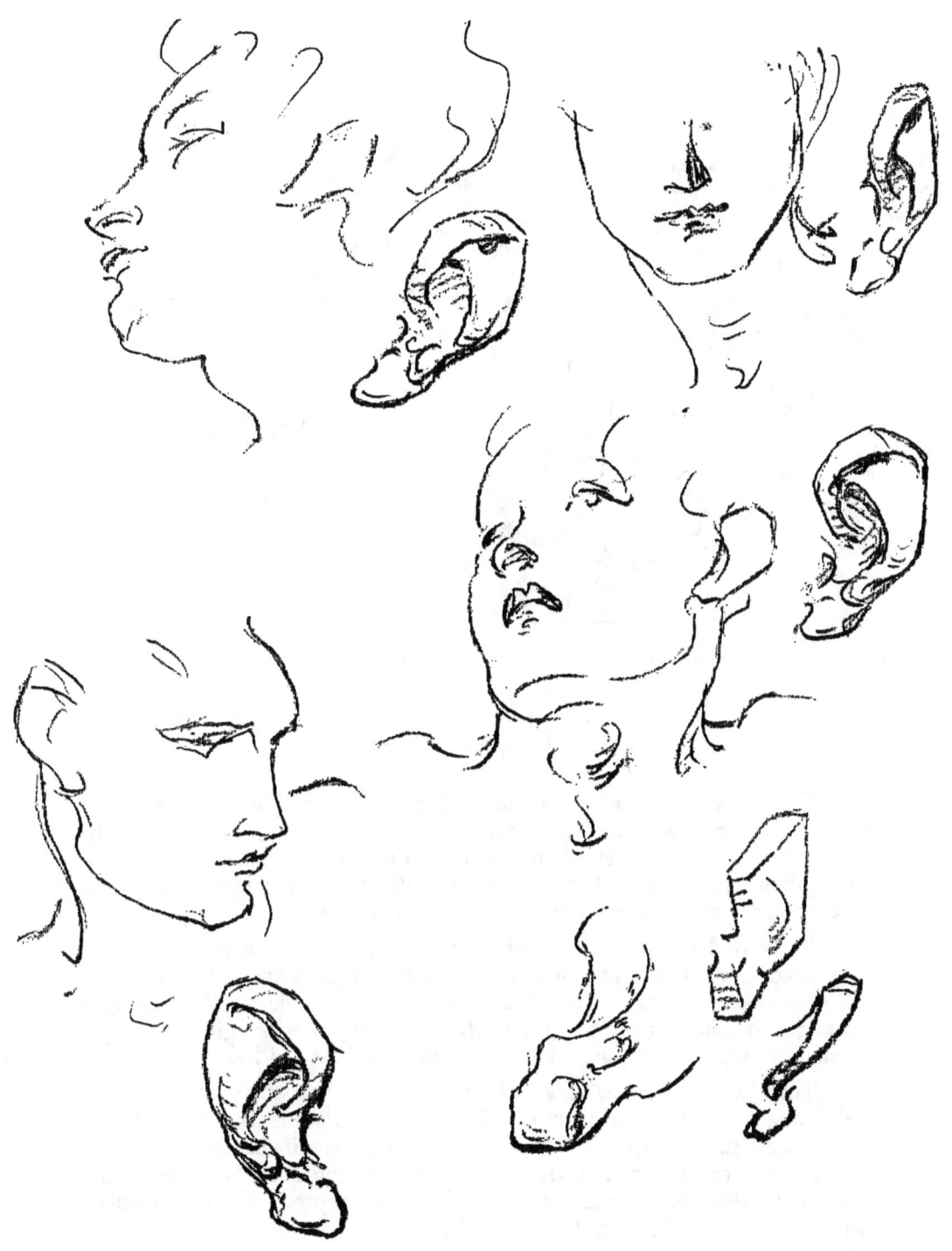

LIGHT AND SHADE

There is light and shade on any object on which light falls. There is light, shade, and cast shadows. The light blends into half light which again blends in a half-tone, that again blends into a shadow. A cast shadow is the shadow of some object falling on some other object or form and bears a resemblance to the objects from which they are cast.

In the parlance of Art the variations of light and shade are in a sense numbered, catalogued and called values. Light, half-tone and shade, making three values and are said to be all that one can keep track of. The grading, passing, and mingling of these, through or into one another, gives the suggestion of other values, but they become more subtle and less definable.

There are many methods, mannerisms and approaches to handling light and shade. One, that form is built by light and shade, that the outline does not exist, the edges of the object are given prominence by light and shade. Another approach is, that an outline drawing is solidified by light and shade, that the outline itself should suggest depth, volume and bulk with only enough shade to give it solidity.

Values are comparative and depend upon their surroundings.

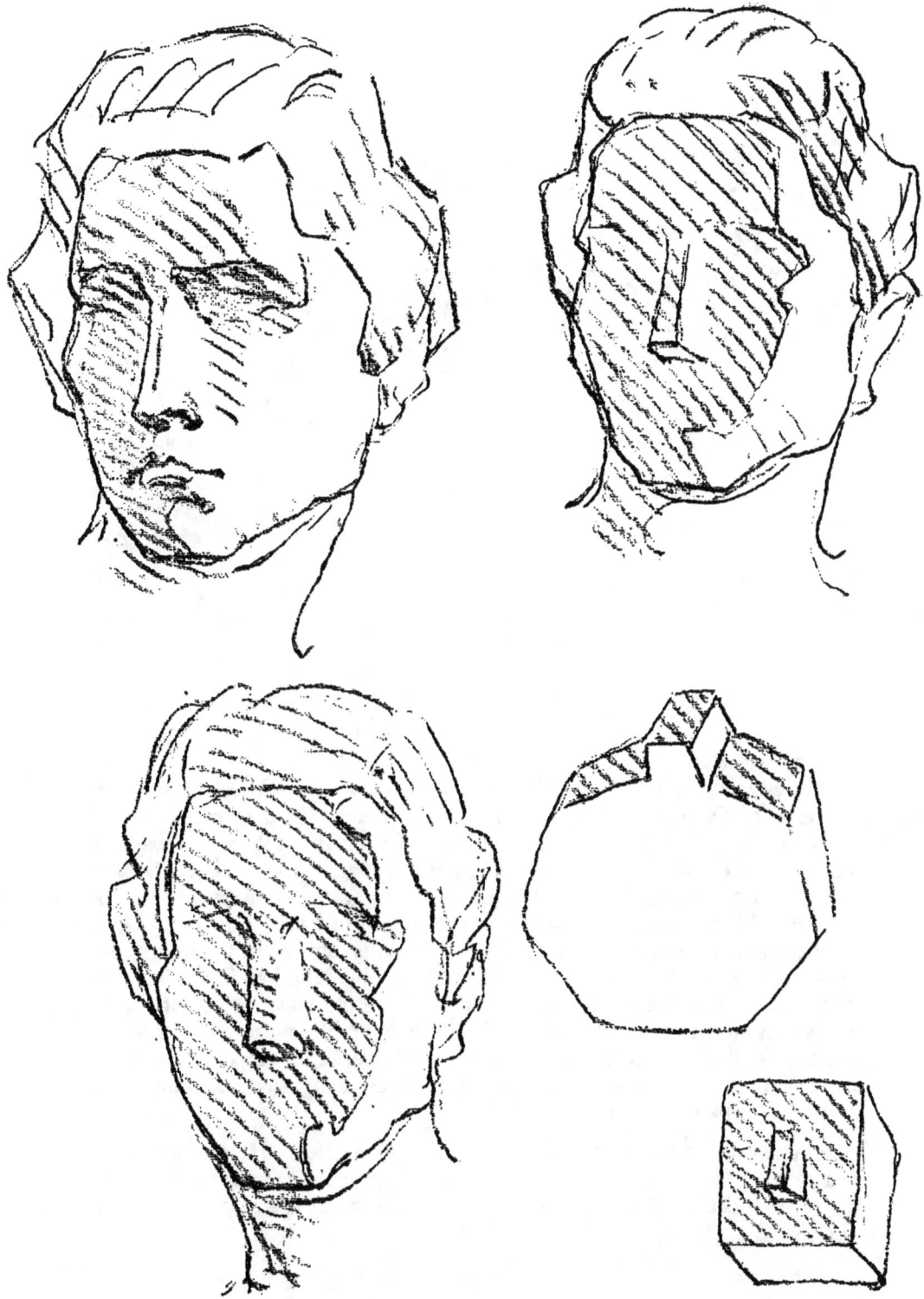

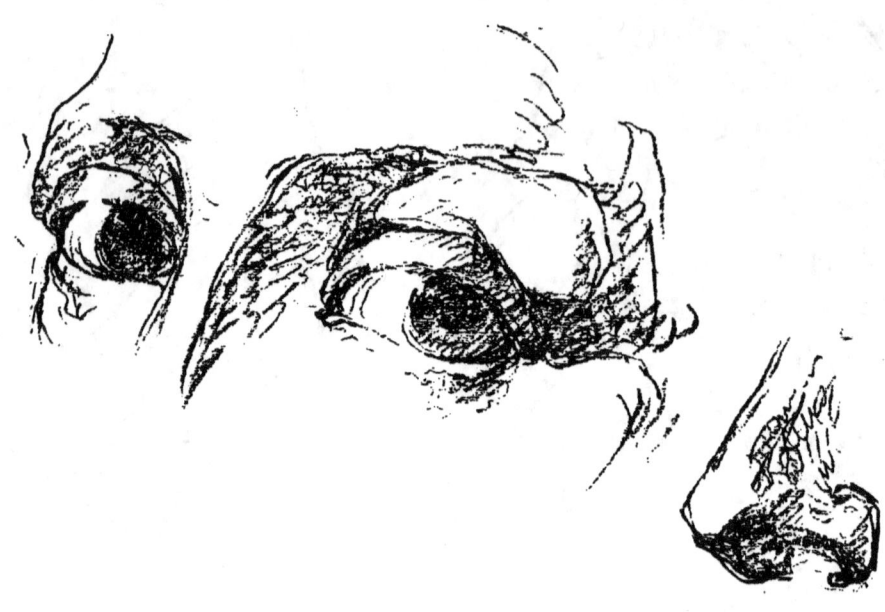

VERMEER OF DELFT

Vermeer, called the perfect painter, Jan van der Meer, known as Vermeer of Delft, 1632-75, was undoubtedly one of the greatest of the old masters. His paintings have incomparable charm. As a colorist he was one of the greatest the world has ever known. At the time he lived he was not universally recognized, and at his death, forgotten. For several generations very little of his private life was known. He married and had eight children and at his death had nothing to leave his family but twenty-six unsold pictures. His widow's affairs had to be put into the hands of a liquidator. Today he is one of the most popular of the old masters, his works are sought by gallaries of all nations. The incomparable charm of Vermeer's pictures is difficult to explain. A master of interior illumination with its delicate notation of values and relative degrees of lighting, nothing could be more brilliant or more faithful to nature.

The head of a young girl, rendered here is considered one of the great portraits of the world. We have tried to analyze his scheme of light and shade with details of the features added. Nothing but the original can give the charm of youth, and freshness of color.

[24]

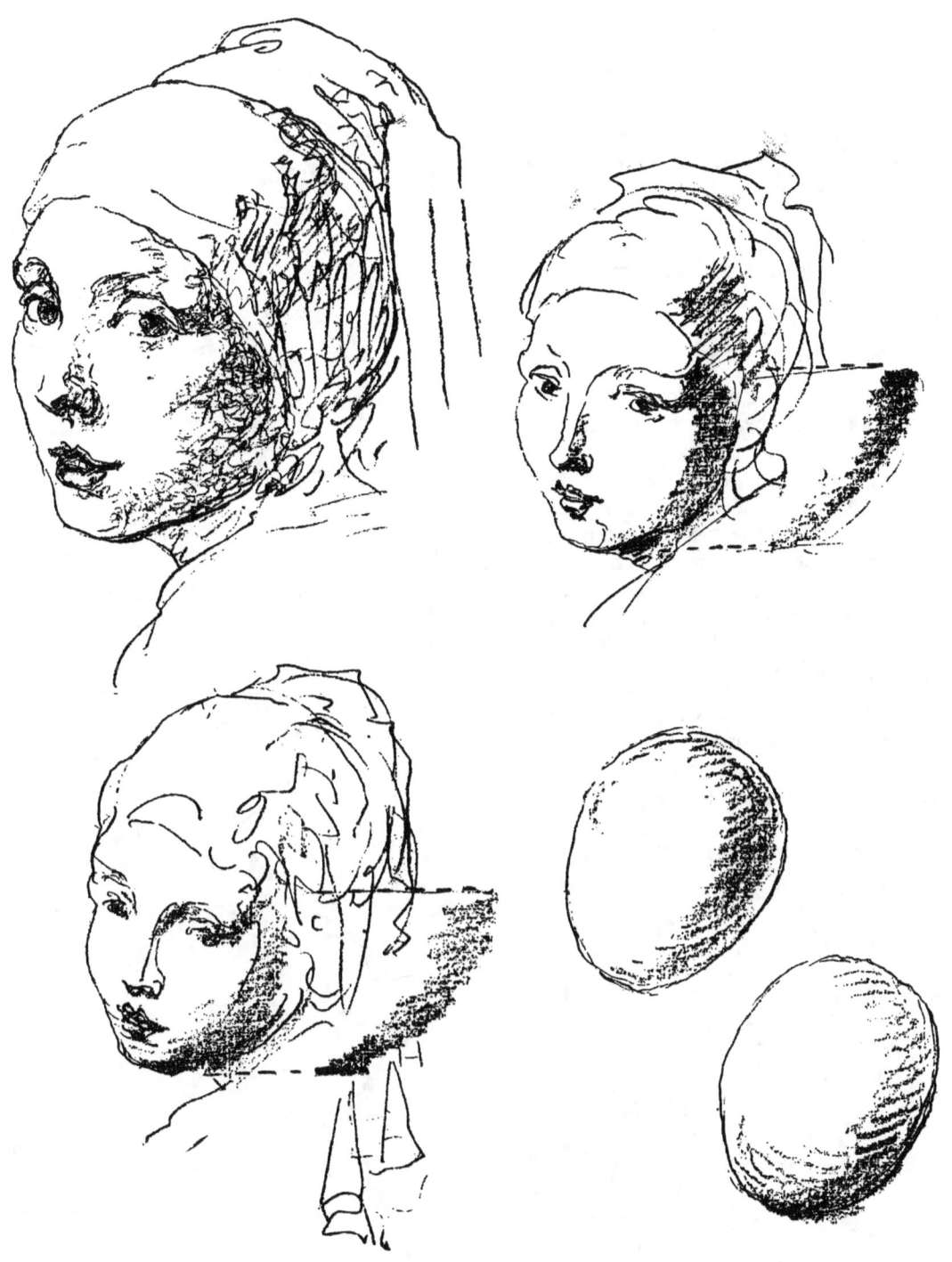

COMPARATIVE
MEASUREMENTS

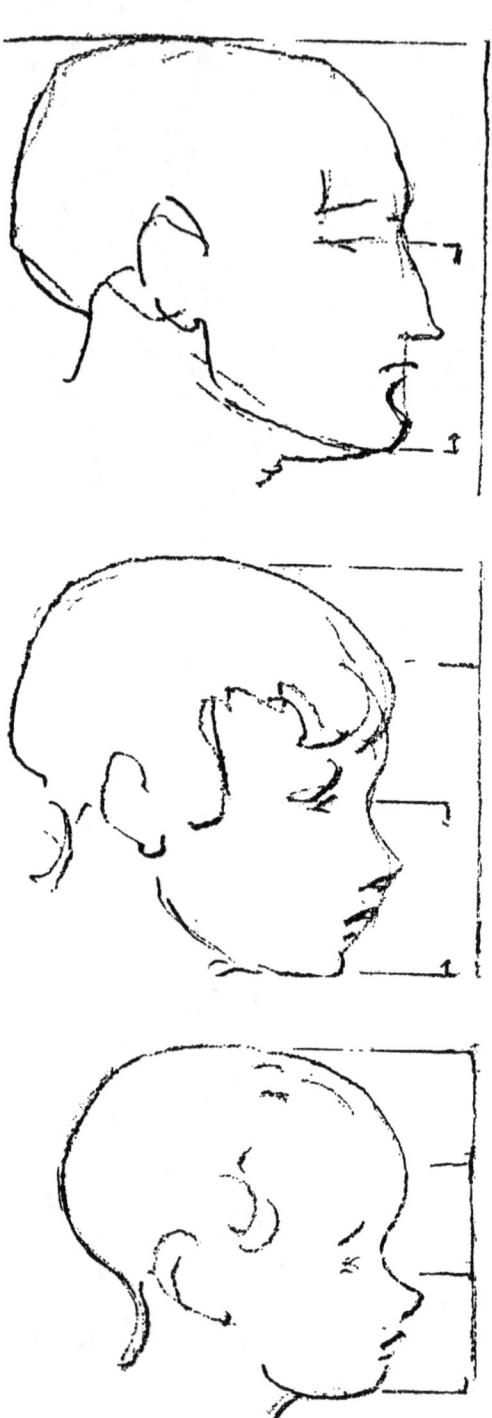

In an adult, from the extreme top to the bottom, the eyes, roughly speaking, are in the middle. The head and face of an infant may be divided in three parts. The eyes placed on the line marking the upper third, from the chin up. In all heads the base of the nose is placed half way between the eyes and chin; the mouth two-thirds the distance from chin to nose. Ages between these two necessarily range somewhere between.

There is also a marked difference in the formation of the head with varying ages. The forehead of an adult recedes, the cheek bones become more prominent, the jaw bone more angular, the whole head in fact more square: while in infancy the head is more elongated and somewhat oval in form. The forehead is full, it recedes down and back toward the brows; the jaw-bones and other bones of the face are diminutive, the neck is small compared to the head.

In youth the face is lengthened and is less round than in the infant. The head above the brows however, is not enlarged in proportion to the increase of the lower part of the face.

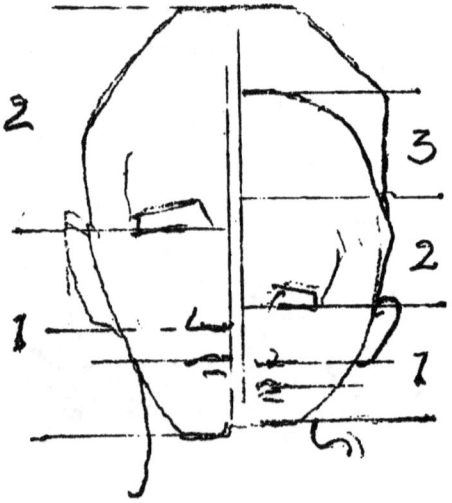

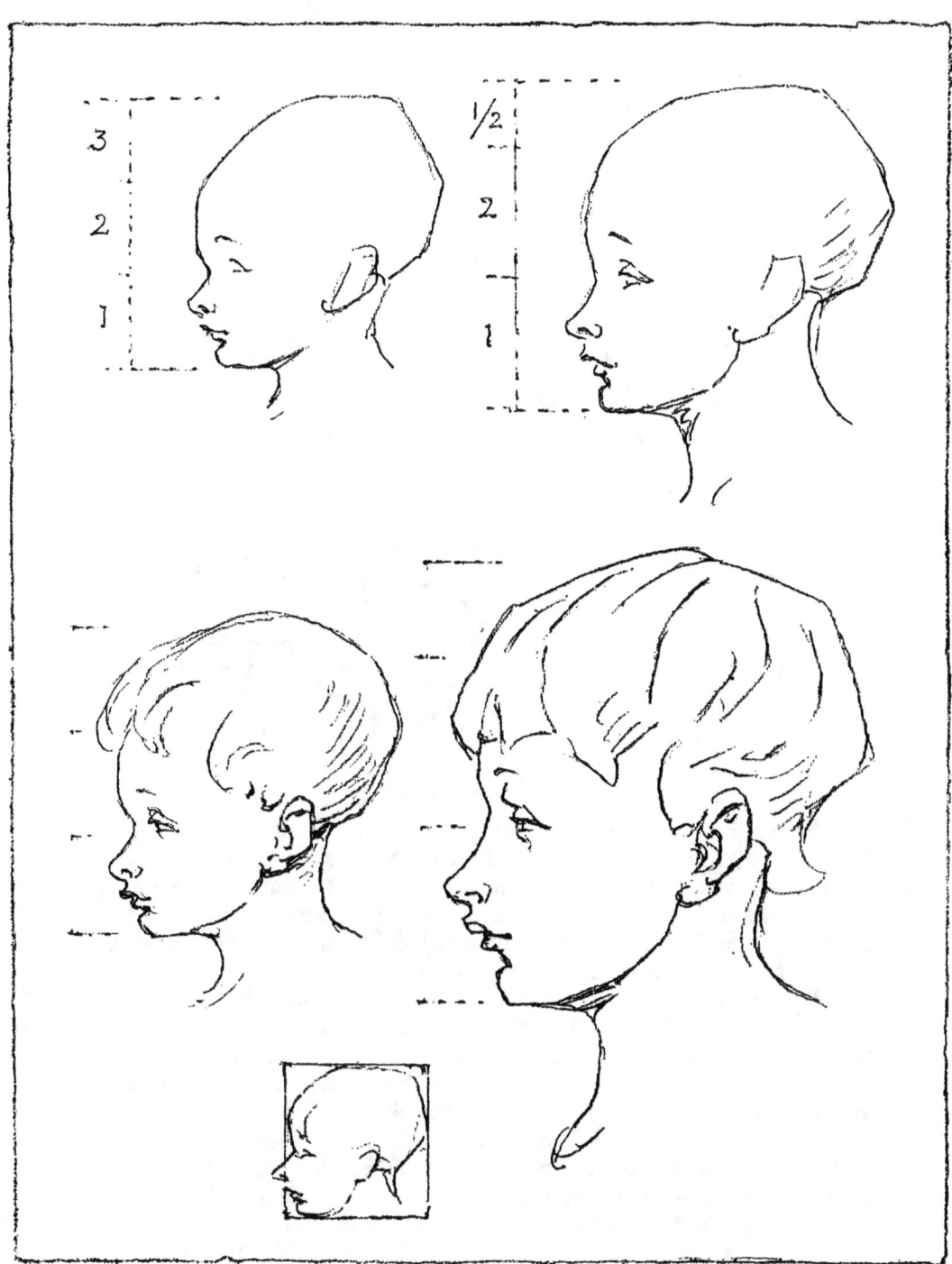

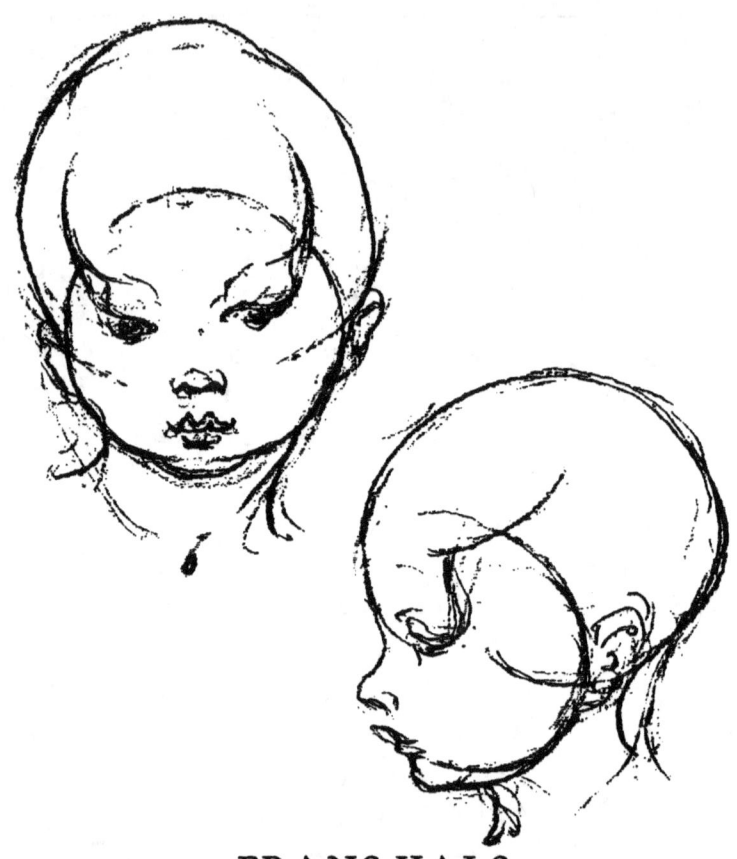

FRANS HALS

Frans Hals was born in Antwerp in 1584 and died in Haarlem in 1666. A portrait and genre painter, a teacher and founder of a national style which was both masterly and vigorous. His immense facility led him at times to be careless and sketchy. Never prosperous despite his long and active life he was always in financial difficulties, so much so, that he had to apply to the municipal council for aid.

In 1664 he was given a yearly pension of two hundred gulden, and in that year, Hals now eighty-four years of age painted his last two pictures' portraits of the managers of the poor-house at Haarlem.

Hals painted his great series of military groups between 1616 and 1639, beginning and ending with the guilds of Citizen Soldiers, the Archers of Saint George and Saint Adriaen, the grouping of which are not only realistic, but have a beauty of pattern and balance that testify to the painter's science of picture arrangement as well as portraiture.

Another brilliant example of the unrivaled power of Hals is the rendering of a child's head accompanying this page, which in the original is elaborate and intricate in detail, where every feature is about to break out in laughter, denoting a masterpiece of fleeting expression.

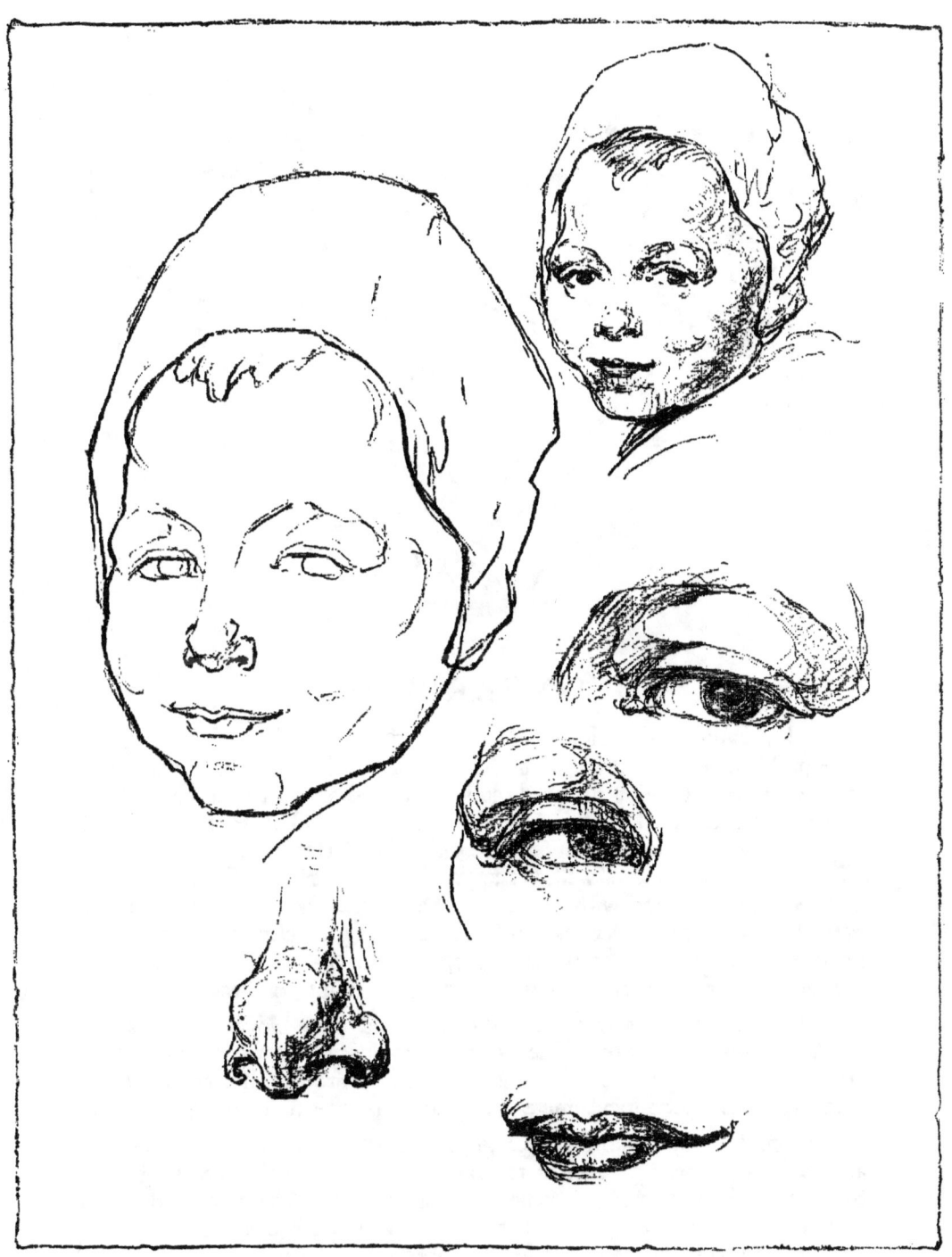

COMPARISONS

The cranium of a child's head differs from an adult in shape, solely as a problem of protection. The head is of an elongated and oval form, its greatest length being in the direction from forehead to the back of the head; its widest portion lies just above the ears. The forehead is full, it protrudes to a marked degree, receding and flattening at the eyebrows. The bones of the face as well as the jaw bones are small. The neck is thin and short as compared with the size of the head. The lumps at the widest part of the head are lower than in the adult as a protection to the temporal region and the ears. The peculiar projection at the back (occiput) is for the same reason, protection, as well as the protruding forehead.

A child's skull is thin and elastic, it will bear blows which would be fatal later on in life. The narrow shoulders and the almost useless arms make a necessity of a bulging forehead to protect the face from the front, and other prominent bulges to protect the sides and back of the head.

From infancy to adolescence great changes take place in the upper as well as the lower portion of the face. From above the face lengthens, the nose and cheek bones become more prominent. The teeth add width and depth at the lower part of the face. Jaw-bones become more angular and pointed, the masseter muscles are more in evidence, and a squareness of the chin is noticeable.

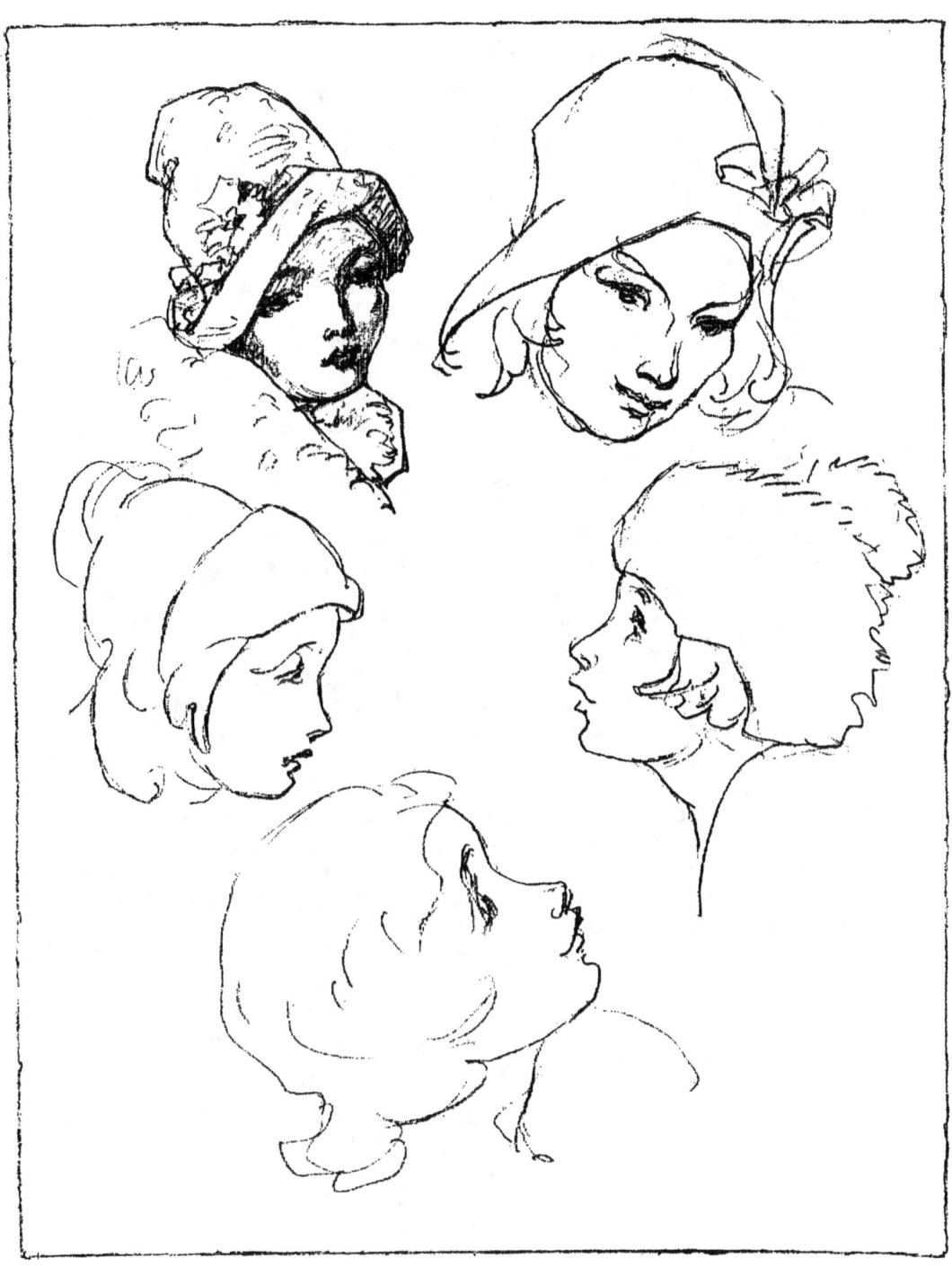

SIR JOSHUA REYNOLDS

Joshua Reynolds lived around two hundred years ago. Son of the Reverend Samuel Reynolds, he was one of eleven children. It is said that at school he was not a good student, that he did not like Latin and shirked other studies. Scribbling and drawing was his pastime. On one of these pages of scrawled Latin are some drawings with a foot-note by his reverend father saying, "These are drawn by Joshua in school out of pure idleness."

The master of the school said that the proper education of such a youth was quite hopeless. By sheer good fortune and with the help of a fine personality and through friendly influence, he was able to leave school in a hamlet not far from Plymouth. Journeying to London he entered as a pupil and apprentice of the artist Hudson. Reynolds was but one of some fifty students and was then seventeen years of age. His apprentice-ship was to have lasted four years, but through some disagreement he left when half of his time had expired.

During the next year he painted many portraits. Among his acquaint-ances was one Commodore Keppel who later was placed in command of the Mediterranean fleet. Keppel took a liking to the painter and invited Reynolds to join him on board his ship the Centurion as his guest.

Leaving the ship at Minorca he went to Rome. From Rome, Rey-nolds visited Florence, Venice and other Italian cities and returned to England in 1753.

His Italia coloring adopted from the Venetian masters did not at first appeal to those that were accustomed to lighter and less somber treat-ment, but gradually he became acknowledged as a master of English Por-traiture.

His life from then on was smooth and placid. Though never married, his love of children led him to adopt the daughter of his brother-in-law. Her sister also came to live with him, so that though a bachelor, he was not without young people in his home. Both nieces married and it was their children who were the inspiration of a number of his most charming and better known paintings.

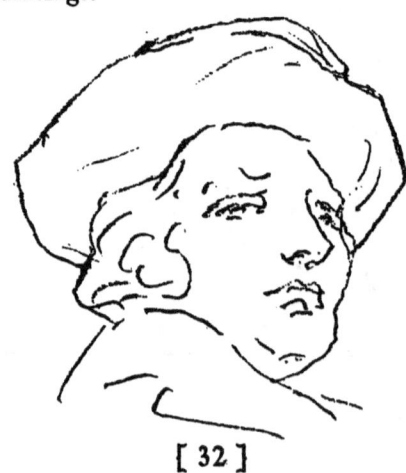

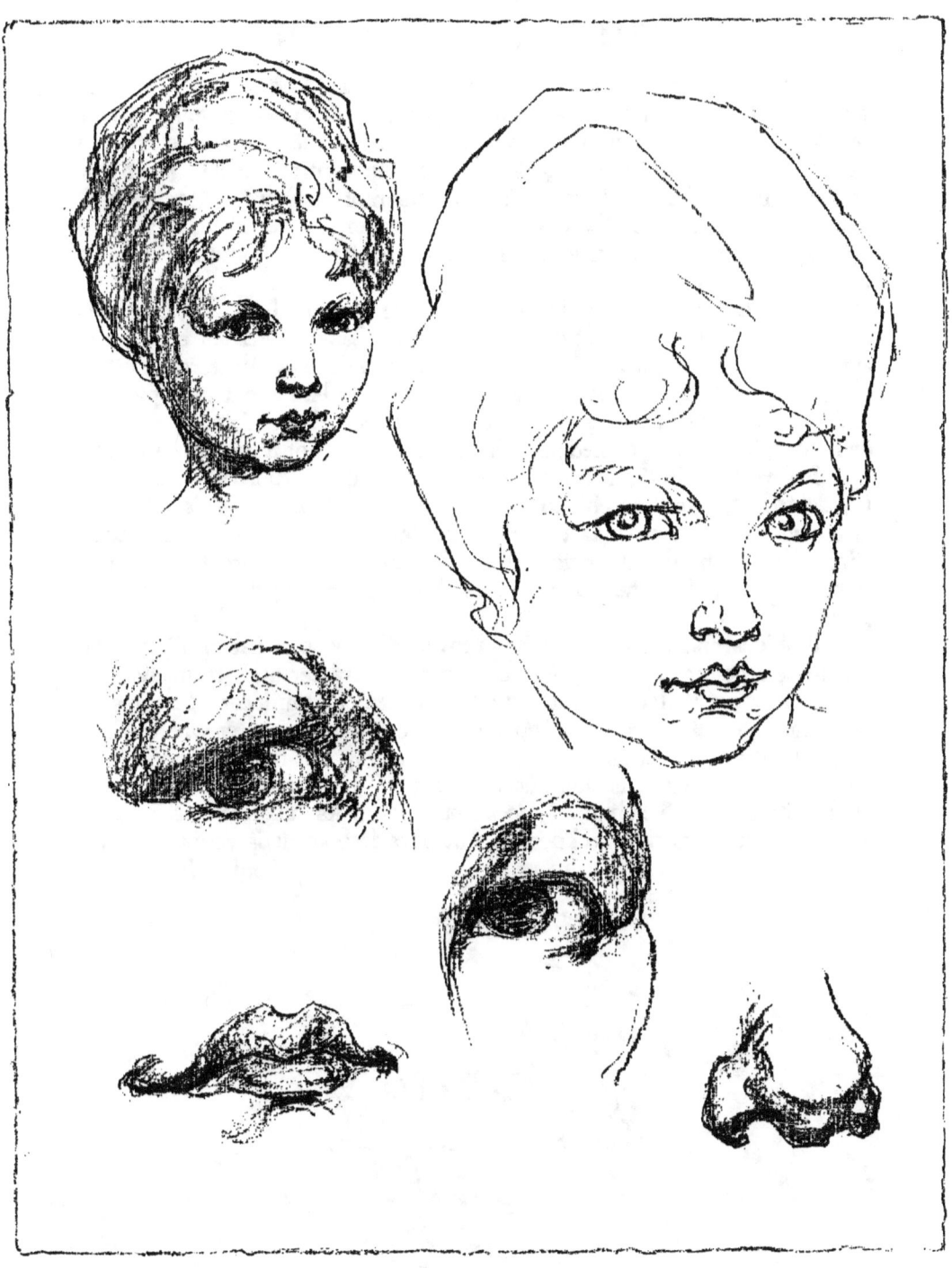

REMBRANDT VAN RYN

Rembrandt was born in the town of Leyden the year 1607. His father, Harmon Gerritsz, was a fairly prosperous miller, owning a mill, several fields, and other property. It was soon seen that Rembrandt's appitude for art was unmistakable. He was apprenticed first to Jacob von Swanenburch and afterwards to Pieter Lastman of Amsterdam, the fashionable portrait painter of the day. In Amsterdam he opened his studio, receiving a number of portrait commissions and became popular both as a painter and etcher.

With his first wife, Saskia van Ulenburgh, whom he married in 1634 he was very happy. The portraits of her at Cassel, Dresden and Berlin are among his finest works. They lived in a fine house at Amsterdam in the Brudstraat, where he made a collection of early Italian and Dutch pictures and prints, as well as glassware, armour and porcelain. Here, surrounded by luxury, he painted, etched and directed the studies of numerous students.

In the year 1642, his wife Saskia died, and for fourteen years after her death Rembrandt and his son, Titus, lived in this richly furnished house. Gradually his popularity as a portrait painter began to wane, his monetary affairs became hopelessly involved. The house and its contents were sold at auction and for the remainder of his days he lived in comparative poverty.

Fashions change, but time has proved that no one has rivalled Rembrandt as a painter in color, light and shade, character and sentiment.

"The eyes and the mouth are the supremely significant features of the human face. In Rembrandt's portraits the eye is the center wherein life, in its infinity of aspect, is most manifest. Not only was his fidelity absolute, but there is a certain mysterious limpidity of gaze that reveals the soul of the sitter. A "Rembrandt" does not give up its beauties to the casual observer— it takes time to know it, but once known, it is yours forever."

—*Emile Michel.*

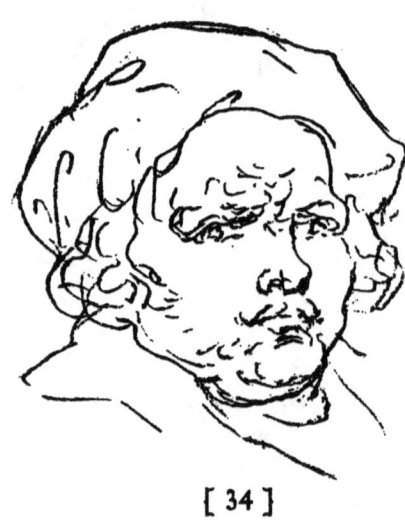

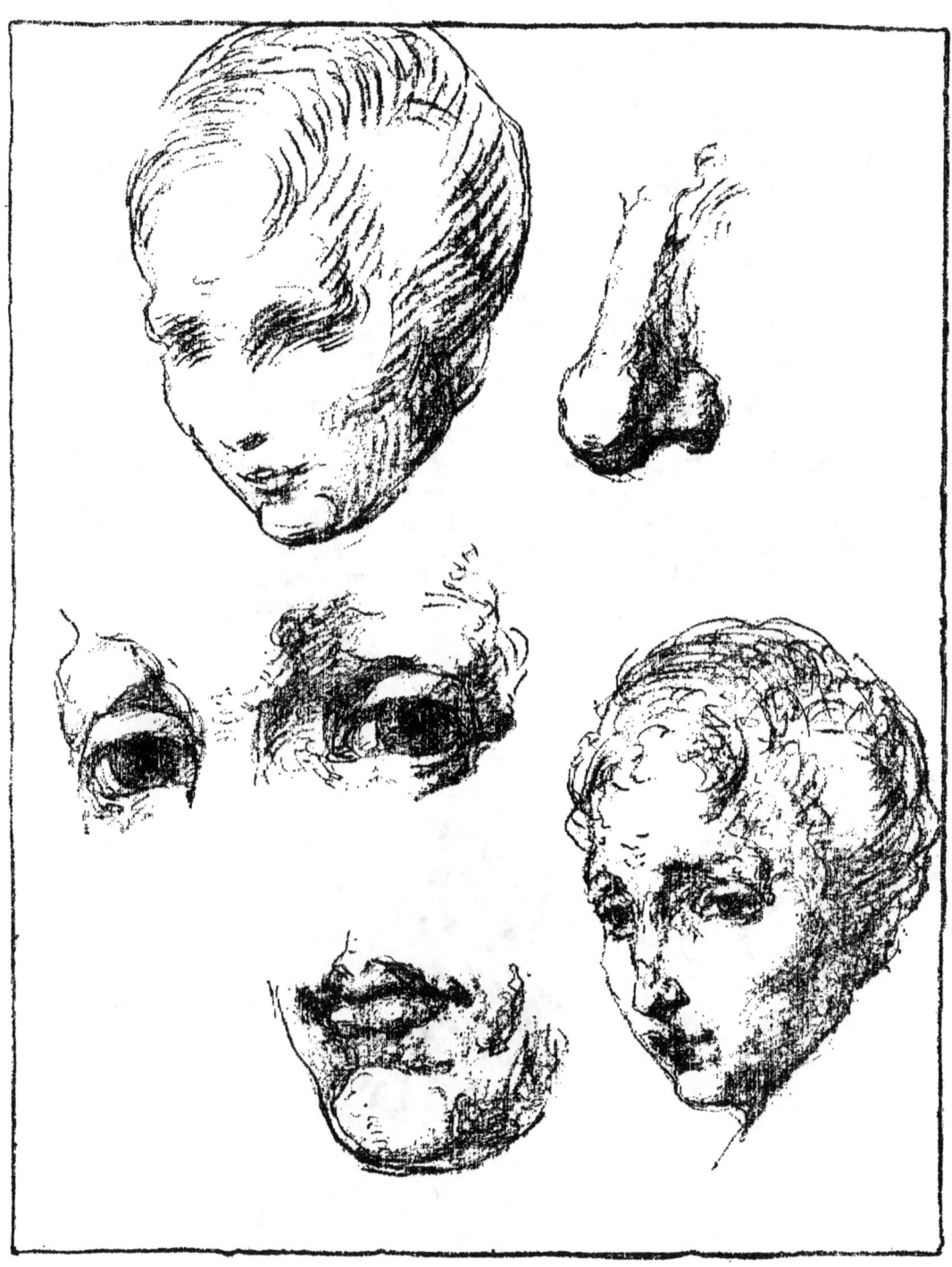

GEORGE WASHINGTON

"Washington was, indeed, in every sense of the world, a wise, a good, and a great man. His integrity was most pure, his justice the most flexible I have ever known; no motives of interest or consanguinity, of friendship or hatred, being able to bias his decision.

"His person, you know, was fine; his stature exactly what one would wish, his deportment easy, erect and noble; the best horseman of his age, and the most graceful figure that could be seen on horseback. Although in the circle of his friends, where he might be unreserved with safety, he took a free share in conversation, his colloquial talents were not above mediocrity, possessing neither copiousness of ideas nor fluency of words.

"On the whole, his character was, in its mass, perfect—in nothing bad, in a few points indifferent; and it may be truly said, that never did Nature and Fortune combine more completely to make a man great, and to place him in the same constellation with whatever worthies have merited from man an everlasting remembrance; for his was the singular destiny and merit of leading the armies of his country successfully through an arduous war for the establishment of its independence, of conducting its councils through the birth of a government new in its forms and principals."

—Thomas Jefferson.

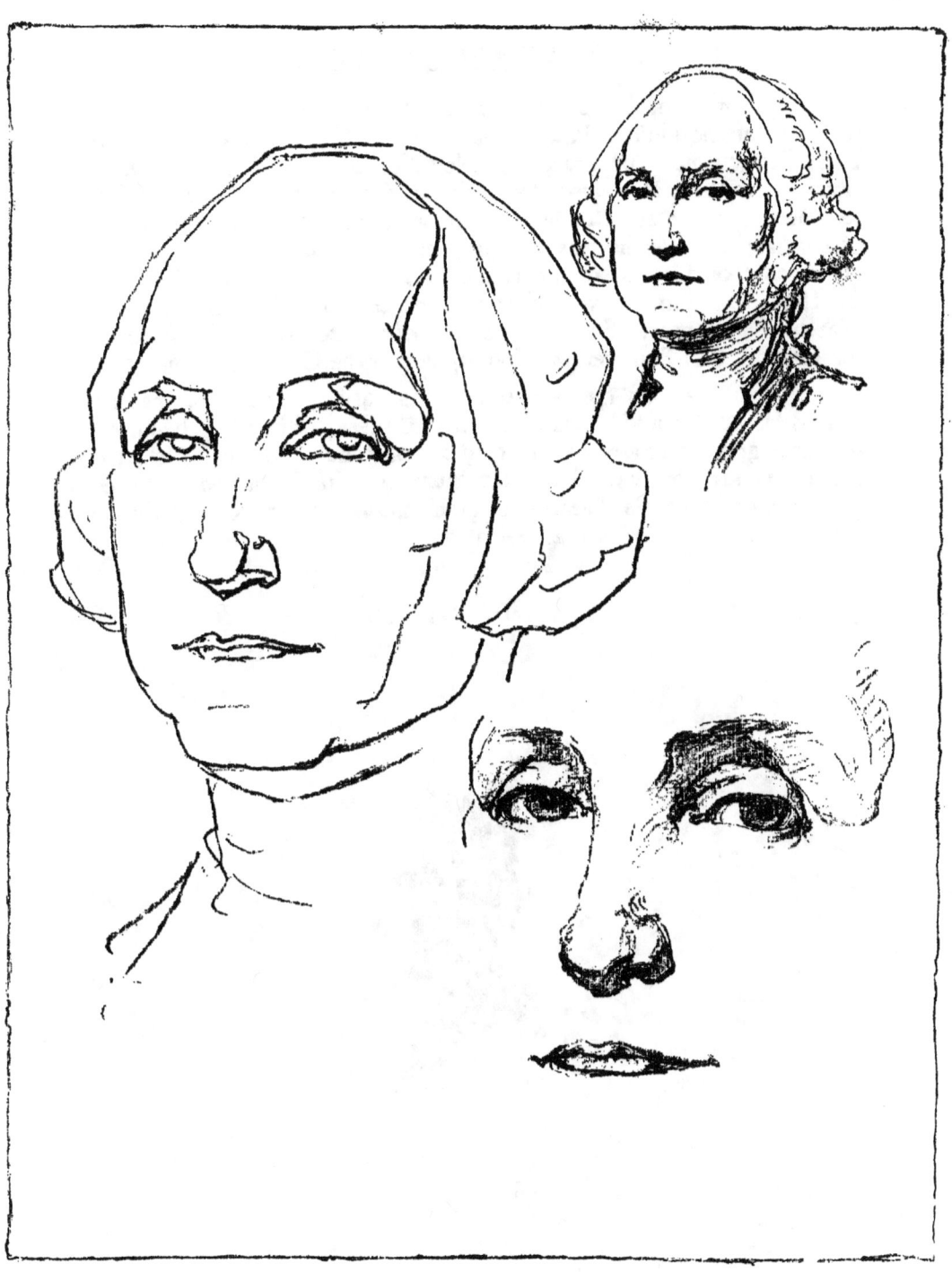

ABRAHAM LINCOLN

Abraham Lincoln, born February 12th, 1809, was the sixteenth president of the United States. Like Washington, he took up surveying. Later he was made postmaster of New Salem. The following year an election for the state legislature took place, Lincoln was successful and became a member from Sangamon county. He now took up the study of law, and in 1846 he was elected a member of the United States Congress and took his seat in the House of Representatives at Washington. In 1860 Mr. Lincoln was elected president and was inaugurated in March of that year. Some of the southern states voted to secede from the Union. Fort Sumpter was fired upon and the Civil War began.

Lincoln's famous Emancipation Proclamation was issued, the slaves were declared free and he was again elected president in 1865 the majority being the greatest of any president up to that time. On April 14th, 1865, the anniversary of the fall of Fort Sumpter, Lincoln attended a special performance at Ford's Theatre in Washington. It was during this performance that Lincoln was assassinated.

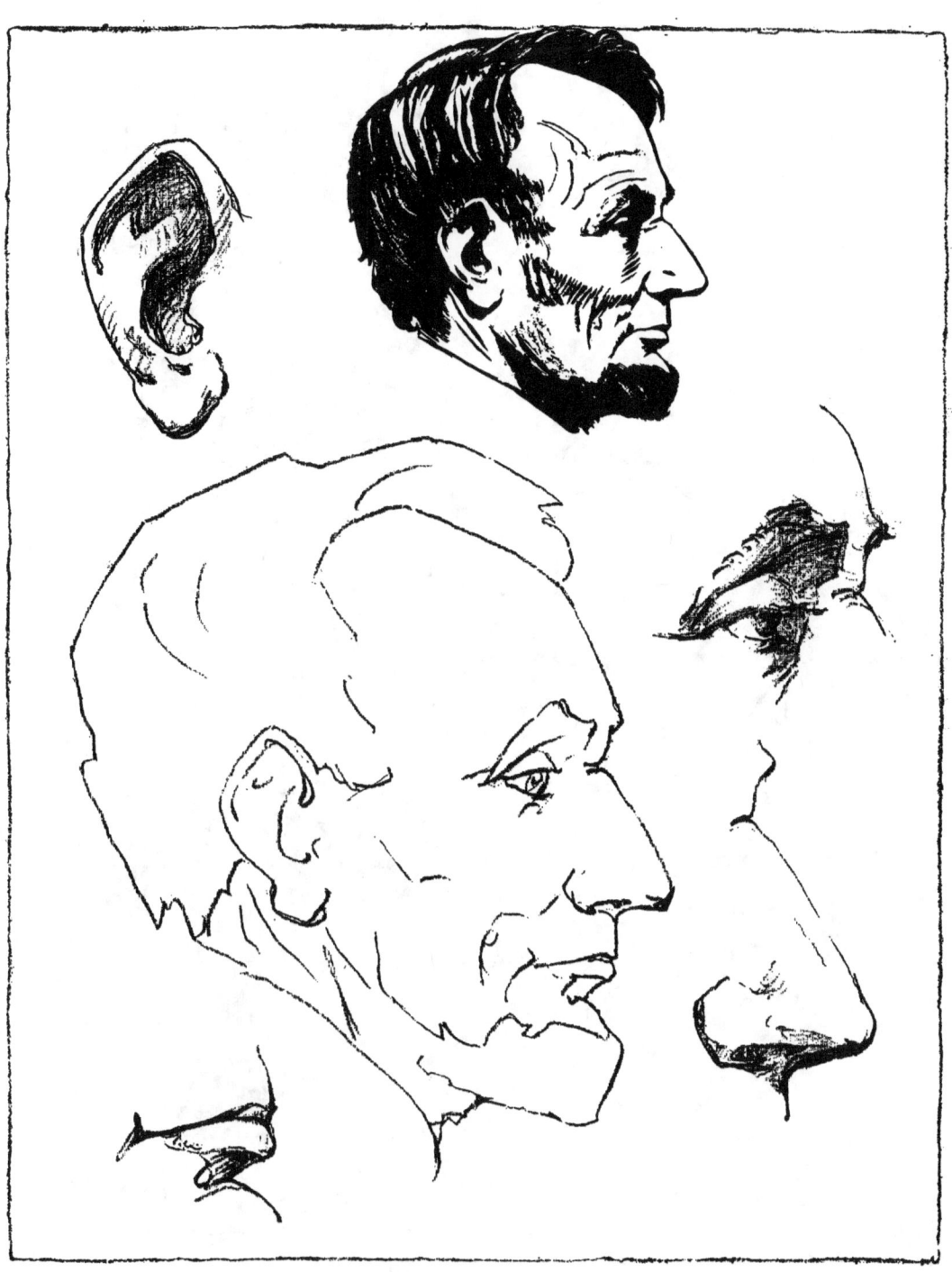

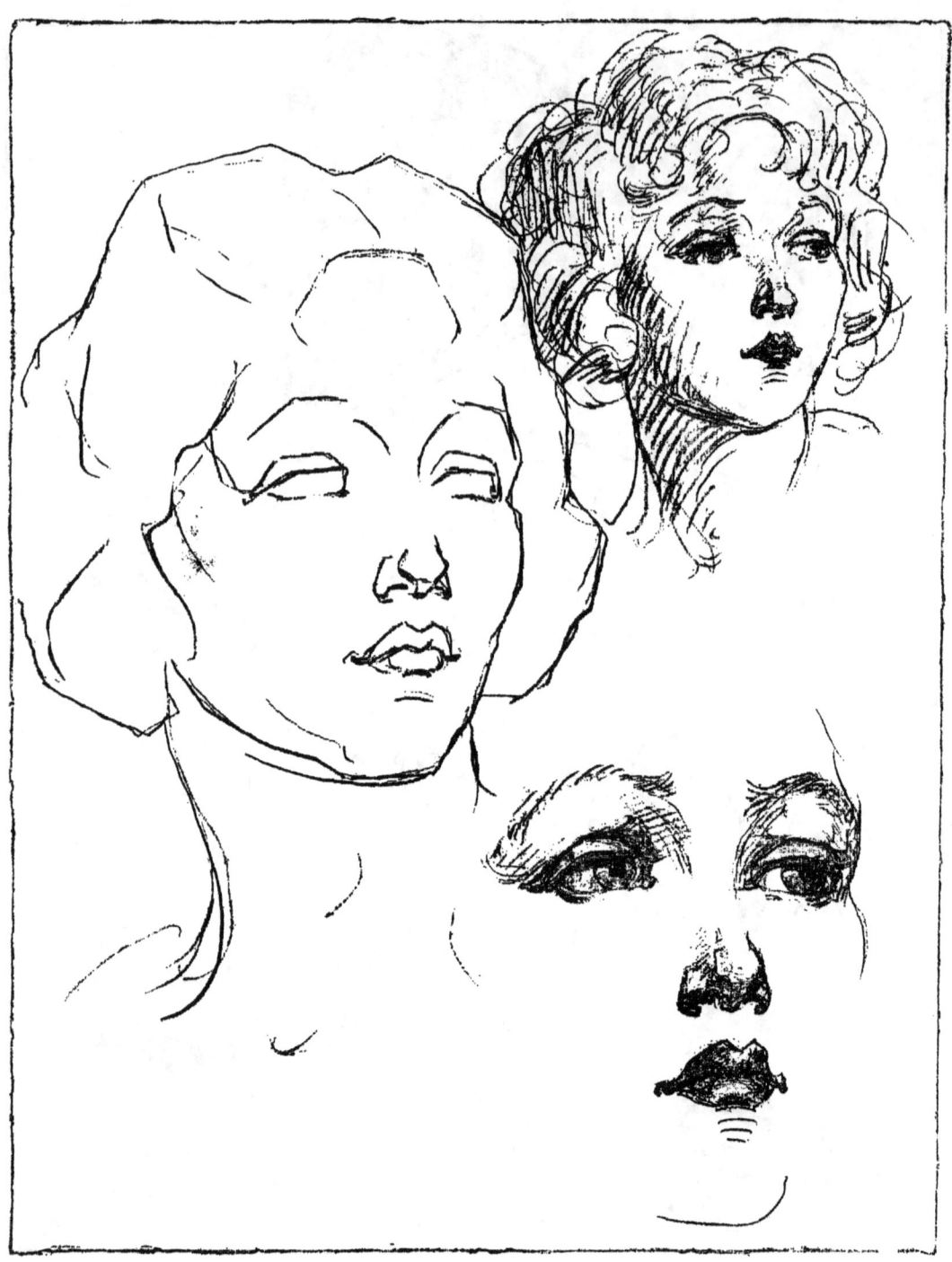

LOUISE ELIZABETH LE BRUN

Madame Louise Elisabeth LeBrun, (nee Vigee) whose father was a portrait painter, taught her to draw. She studied painting under both Doyen and Joseph Vernet. At sixteen she had painted many portraits and was looked upon as a bright and coming artist.

About this time she married LeBrun who was what would be called today a high-powered picture salesman. What her future reputation would have been if it were not for LeBrun, is hard to say. He drummed up orders to such an extent that she was kept busy night and day, and he kept the money.

At the out-break of the French Revolution, Mme. LeBrun went to Italy and painted portraits and other pictures at Naples. Before returning to France she visited Germany and Russia. Later on her travels took her to England, Holland, and Switzerland. Parma, Bologna and Berlin honored her with associate memberships to their academies.

It may be well to ponder over the salesmanship of LeBrun, even though he appropriated most of the money. He shouted her name from the housetops. If hard work is genius, he supplied the work, for during her life-time Mme. LeBrun painted six hundred and sixty-two portraits, two hundred landscapes and fifteen historical pictures.

Though Mons. LeBrun had passed on, the Madam at eighty years of age, was still painting portraits. Many of her works grace the galleries and museums of France, Italy and Spain.

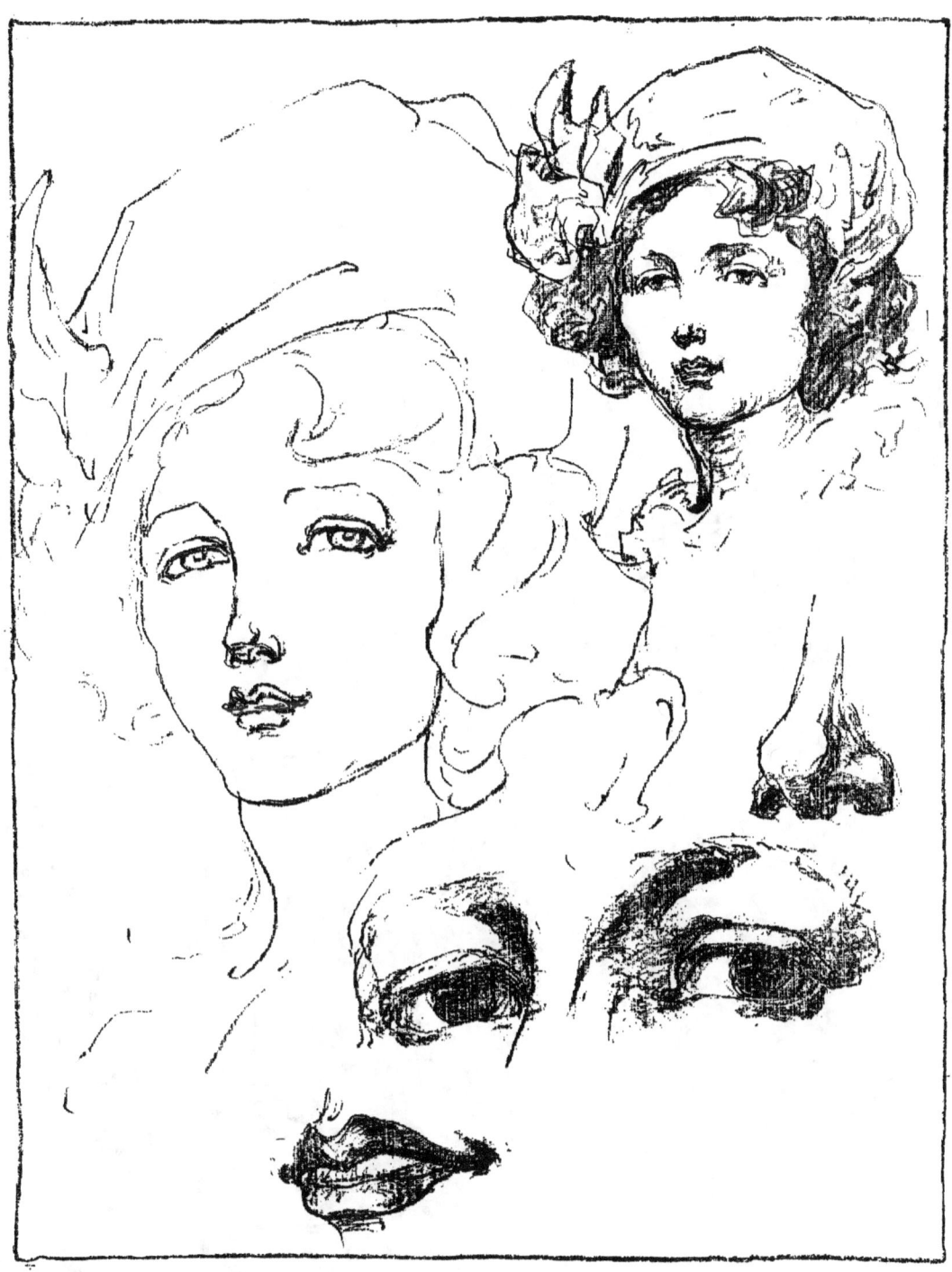

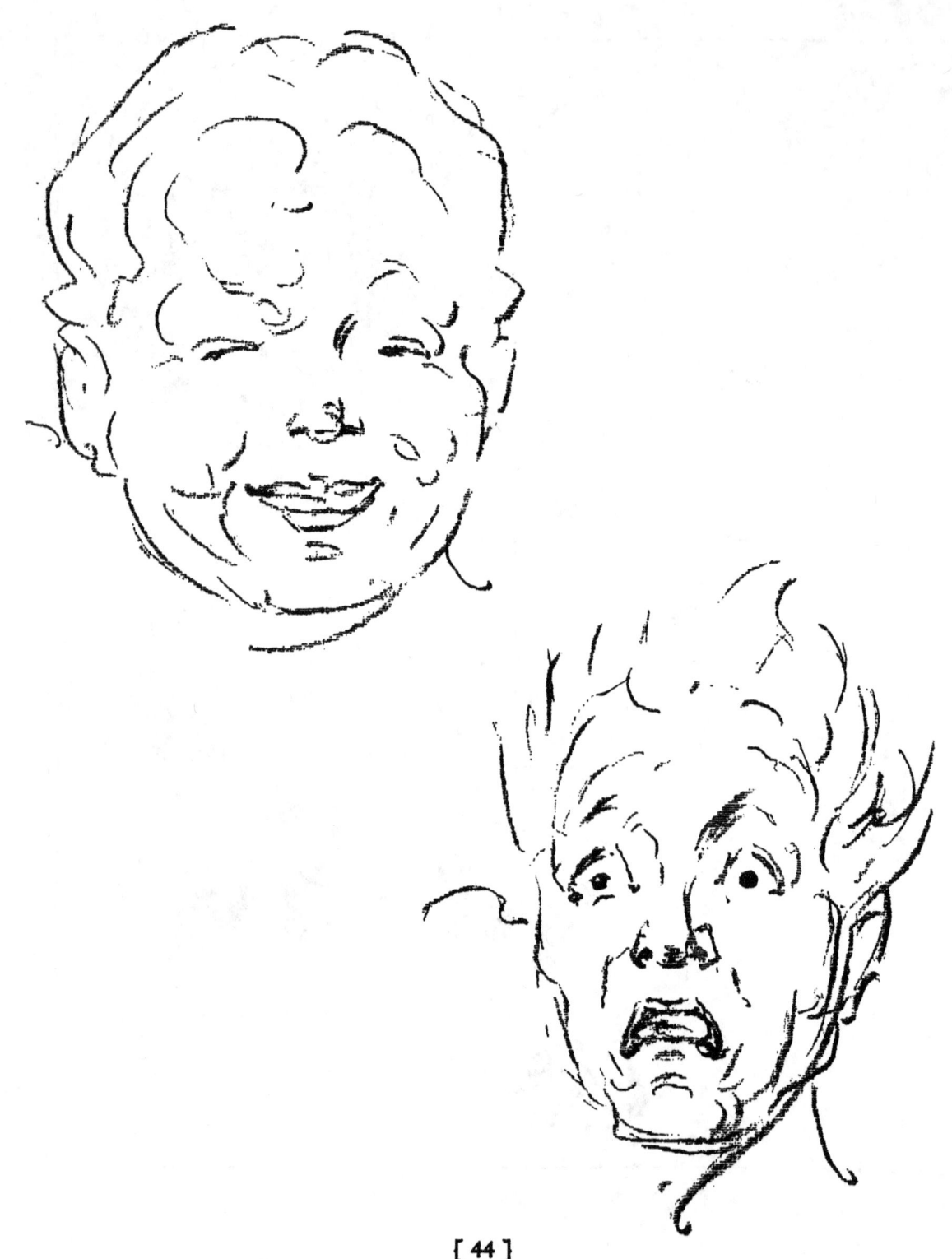

[44]

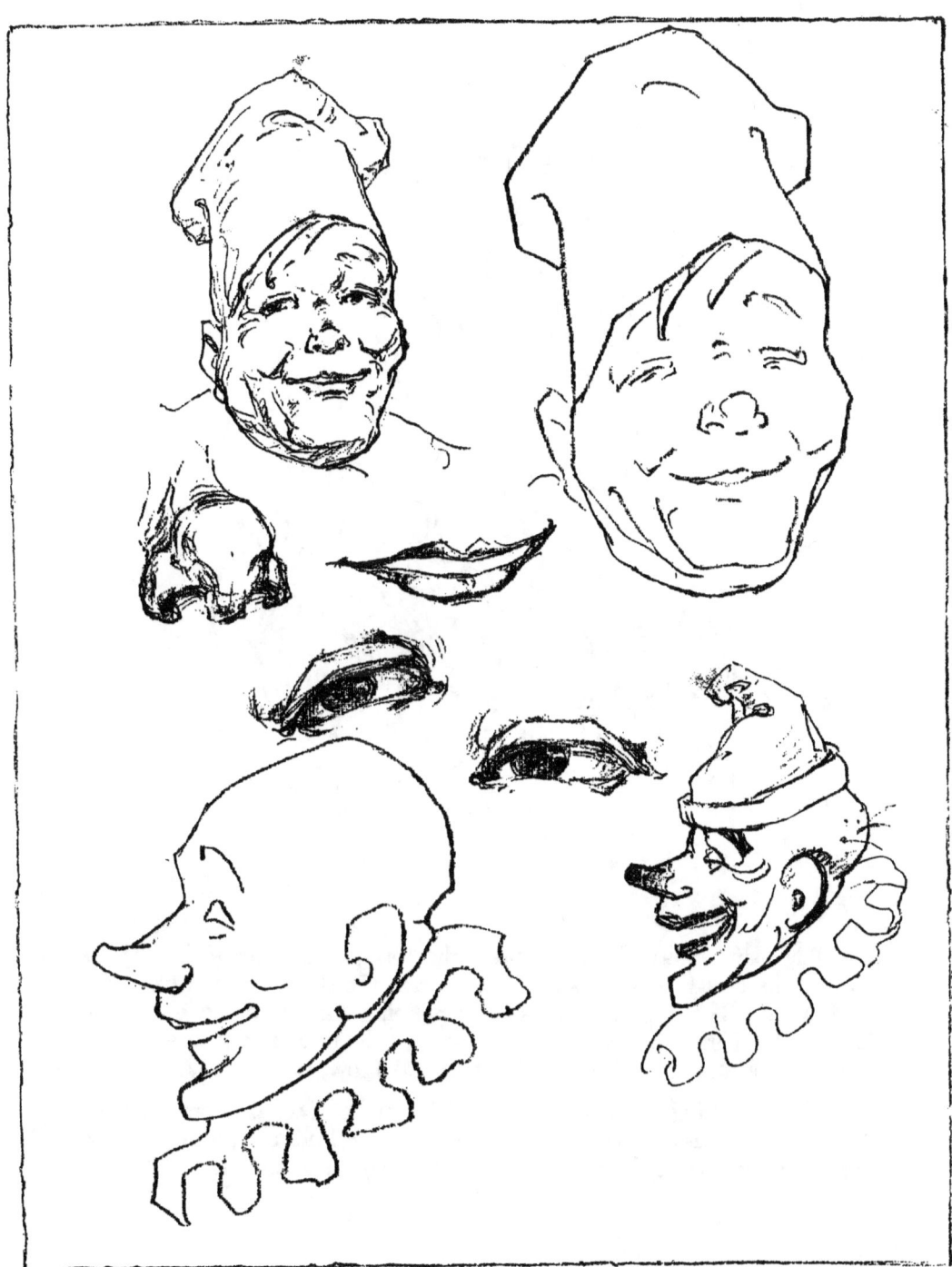

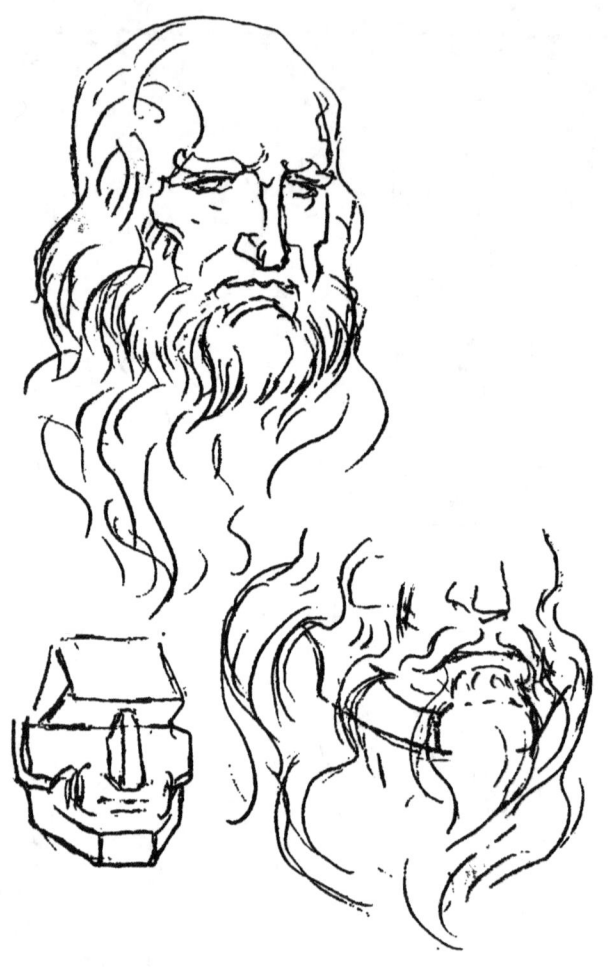

The hair or beard must express the form from which it springs as well as the mass it covers, and must indicate the shape beneath like folds in drapery. The coils of hair have a beginning and an ending, and again like folds it clings in places close or tight to the head and face or to fall away in the form of twists or coils about the brow, ears or neck.

The rendering of the supposed self-portrait of Leonardo on this page illustrates the passing of the beard round the cylindrical portion of the lips as in contrast to the planes of the lower jaw-bone and chin.

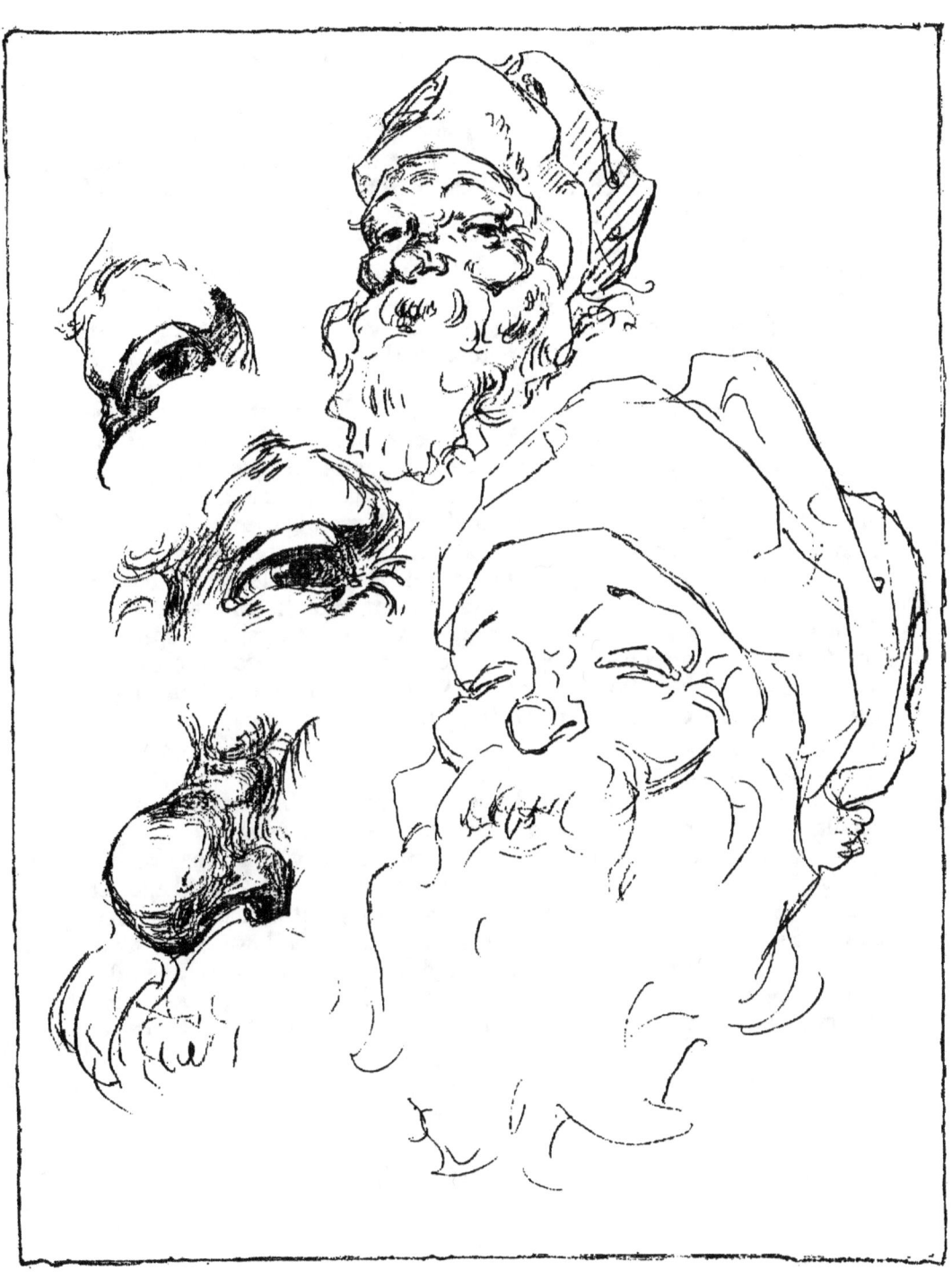

FEATURES IN PROFILE

It has already been suggested that the head of an adult should first be divided into two parts by a line passing through the lower eye lid, the lower half again divided equally, marking the base of the nose, the mouth two-thirds up from the chin. Yet it is the breaking or the variation of these rules that give character and personality to a head.

The front of the skull at the prominence over the eye-brows have no relation to the form of the brain, yet they and the ridges which project toward the temples are reinforced bone as a protection to the eye. The eye socket and eye sets back of this protectory ridge, (the frontal bone) which diminishes in width as it approaches the temple where it turns on the outside at the temporal border.

The plane of the eye sockets slope inward from the frontal bone making a decided angle from forehead to cheek. From this concavity the eye-ball and enveloping lids are encased. The upper lid and eye open or closed follow the downward plane from forehead to check bone. Both upper and lower lids show a front and side even when seen directly in profile, as well as the skin furrows that occur beneath the lower lid.

The nasal bones are a protection to the eyes as well as forming the root of the nose. It is attached to and fuses into the frontal bone at the glabella. The nose is subdivided by a middle cartilage, (the spetum) and flanked by planes and wings. These planes are formed by cartilages named the upper and lower laterals. When seen in profile, the upper lateral forms the descending plane from nasal bone to wing. The lower lateral forming the bulbus end and sides to the tip of the nose. The nostril is seen as a cavity at the under plane of the nose, it widens out as it approaches the wing which marks its termination. The wing is more angular than round and is known as the buttress of the nose.

The mouth seen from the side follows but half way round the cylinder into which the teeth are set. The upper lip is more angular than the lower and has a central wedge shaped body with a curved slender wing that disappears as it passes in the pillar of the mouth. The lower lip is more rounded in form, has a groove in the center and a lateral lobe at the side. In drawing a mouth from the side, try to turn the lips a little more round the cylinder at its profile than you see; this gives a sense of another dimension.

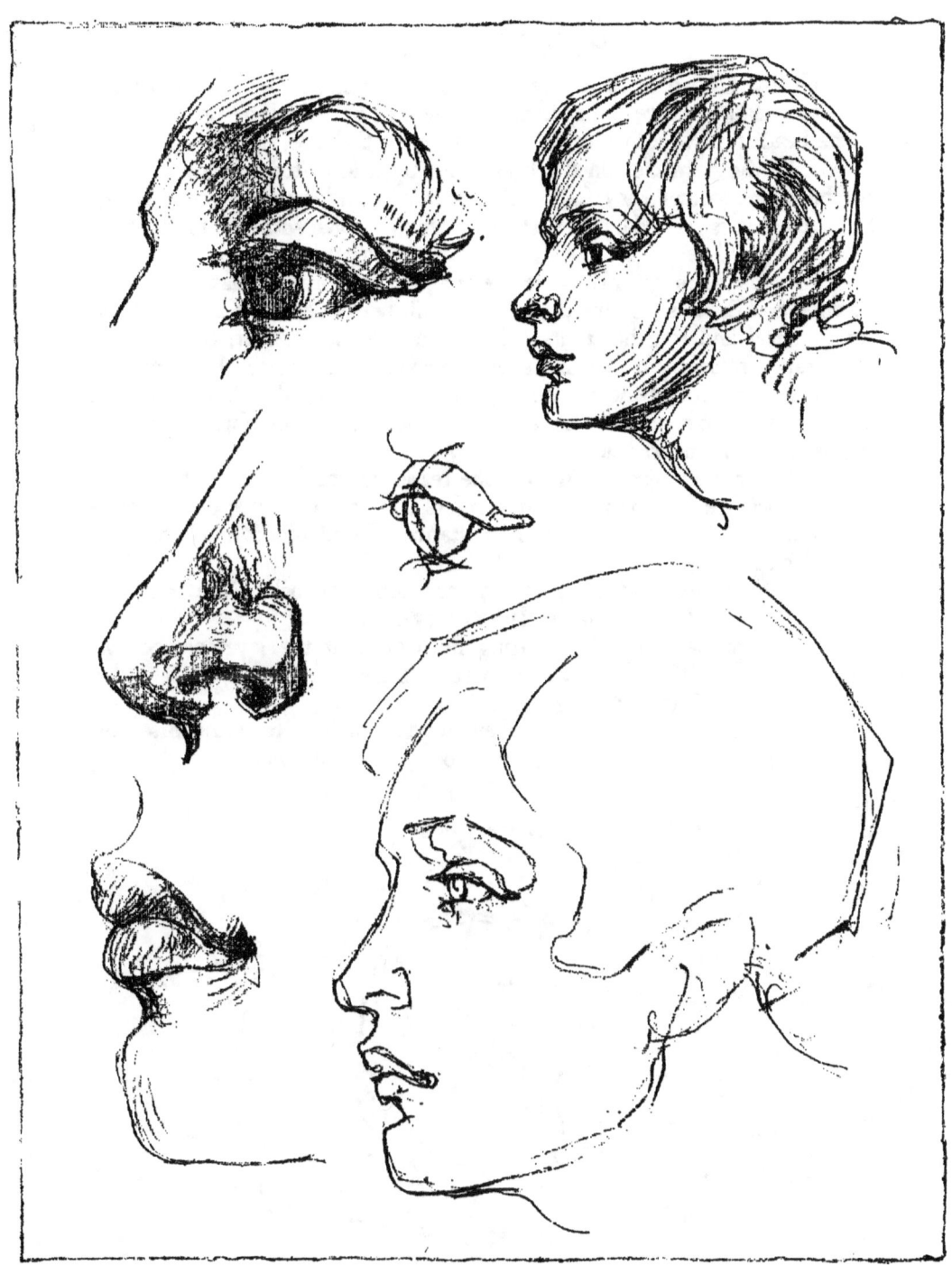

PERSPECTIVE

Unless a head is at eye level it must necessarily be in perspective. When a head is above the spectator, obviously he is looking up. Not only is the head in perspective, but every feature of the face; eyes, nose, mouth, ears. Like the barnacles on the hull of a ship, the features follow the lift. In the same manner they follow the upward trend, or its reverse. Everything to that is secondary. The features must travel with the mass of the head.

Perspective must have some concrete shape, form or mass as a basis. A cube or a head seen directly in front will be bordered by parallel lines; two vertical and two horizontal. These lines do not retreat, therefore, in appearance remain parallel. As soon however, as they are placed so that they are seen from beneath, on top or from either side, they appear to converge. This convergence causes the further side of the object to appear smaller than the nearer side.

It is not our object to involve the reader in the labyrinth of perspective as a science. Perspective simply refers to the appearance of objects as influenced by the position and the distance of said object from the eye.

The rules are:

> First—Retreating lines whether above or below the eye tend toward the level of the eye.

> Second—Parallel retreating lines meet at the level of the eye. The point where parellel retreating lines meet is called the vanishing point.

As objects retire or recede they appear smaller. It is the first rule of perspective—on this, the science of perspective is built.

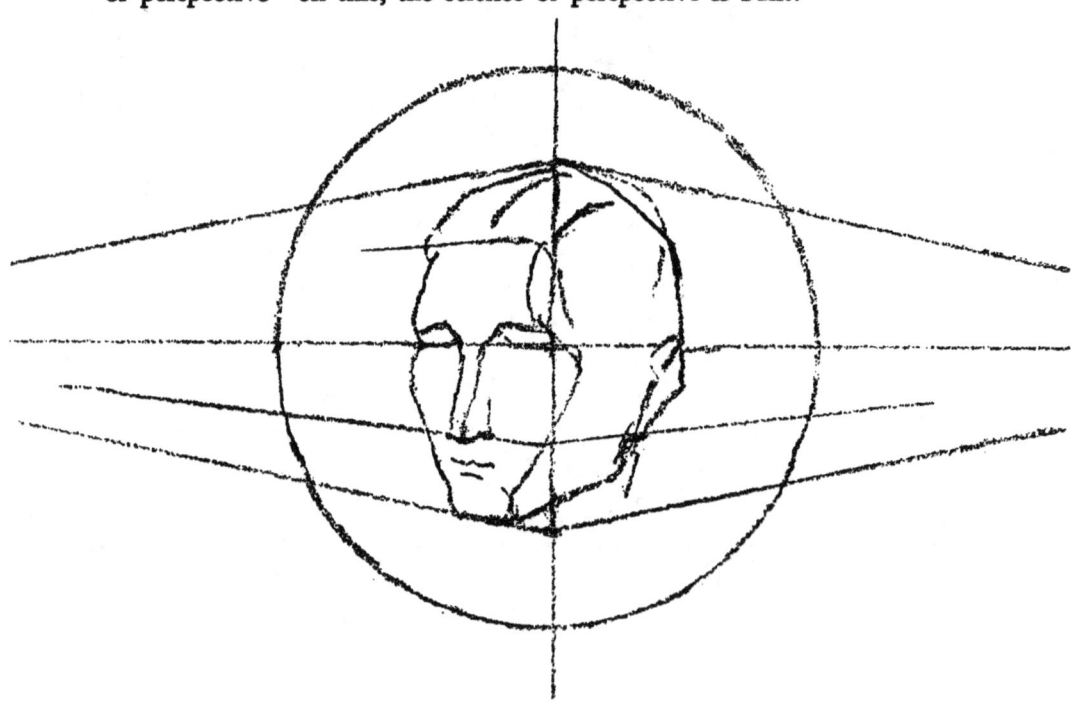

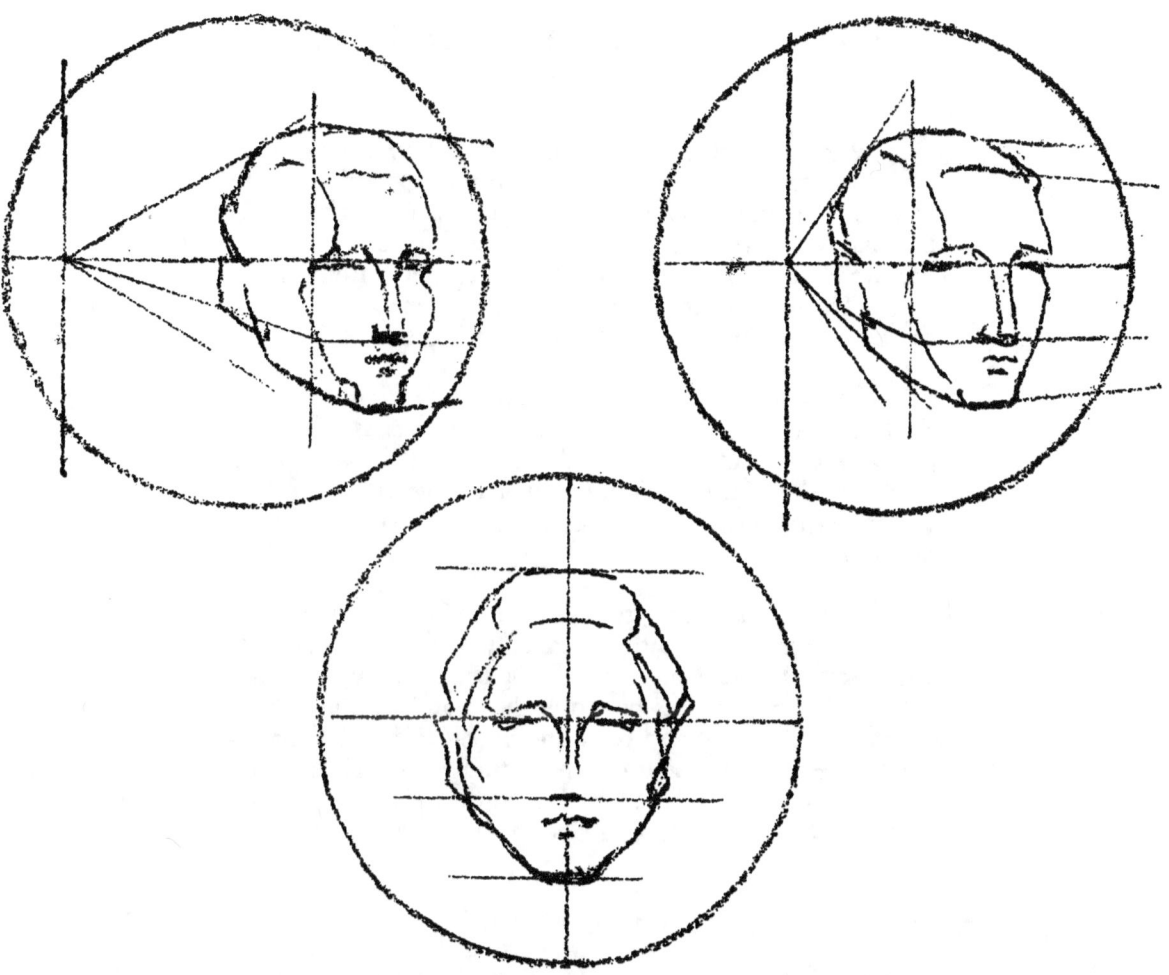

Take a circle for an illustration. Draw a horizontal line through its centre, then a line at right angles. Where they intersect place a point of sight. Should a head be placed directly in the center of this circle the center of the face would correspond to the root of the nose, on a line level with the lower border of the eyes. The horizontal line is called the horizon and is at eye level at the height of the eye. The features will parallel the horizontal line. If the head remains in the same position and the observer steps to one side, the side of the head comes within the range of vision and the relative position of the head and features are perspectively changed, but not the proportions. The distance away is the same.

Looking directly toward the corner of a head at close range, it would be necessary to change the point of sight. The lines that were parallel with the horizon are no longer parallel, but drop or rise to meet the horizon at some point to form vanishing points.

[51]

THE HEAD - ABOVE EYE LEVEL
FRONT

When a head is tilted or curved downward the lines of a face curve downward. When tilted upward or backward the direction of the features turn up or backward in like manner. These curved lines and oval forms are too indefinite. It is difficult for the eye to register on any given point. The block form suggests mass and planes which again carries a suggestion of perspective and foreshortening.

If you see under the chin, you are looking up under the head, meaning the eye level of the observer is below the object. The base of the nose and the base of the two ears are level when seen at eye level, but when above, that is seeing the head from beneath, then all the lines above the horizon or eye level descend.

Most of the forms seen in nature are foreshortened, that is in perspective, with the exception of the lines at right angles with the point of vision. If the head is thought of as a cube with straight lines bounding head and face it will be found that the front and back are oblong and that the sides are square. The top of this cube would represent the head, the bottom the chin, the outside borders the cheek-bones. Here a definite and simple shape of the head is given.

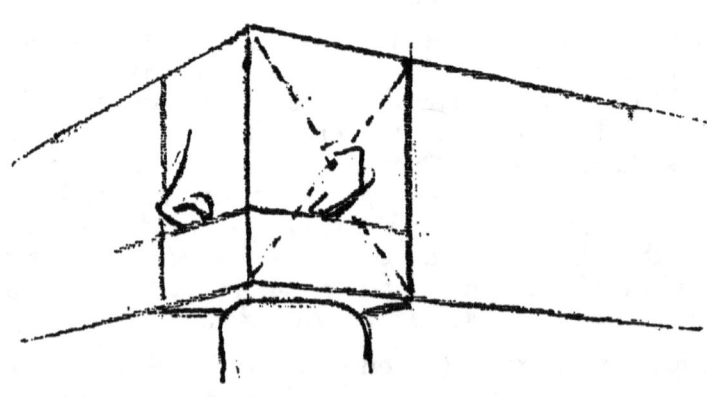

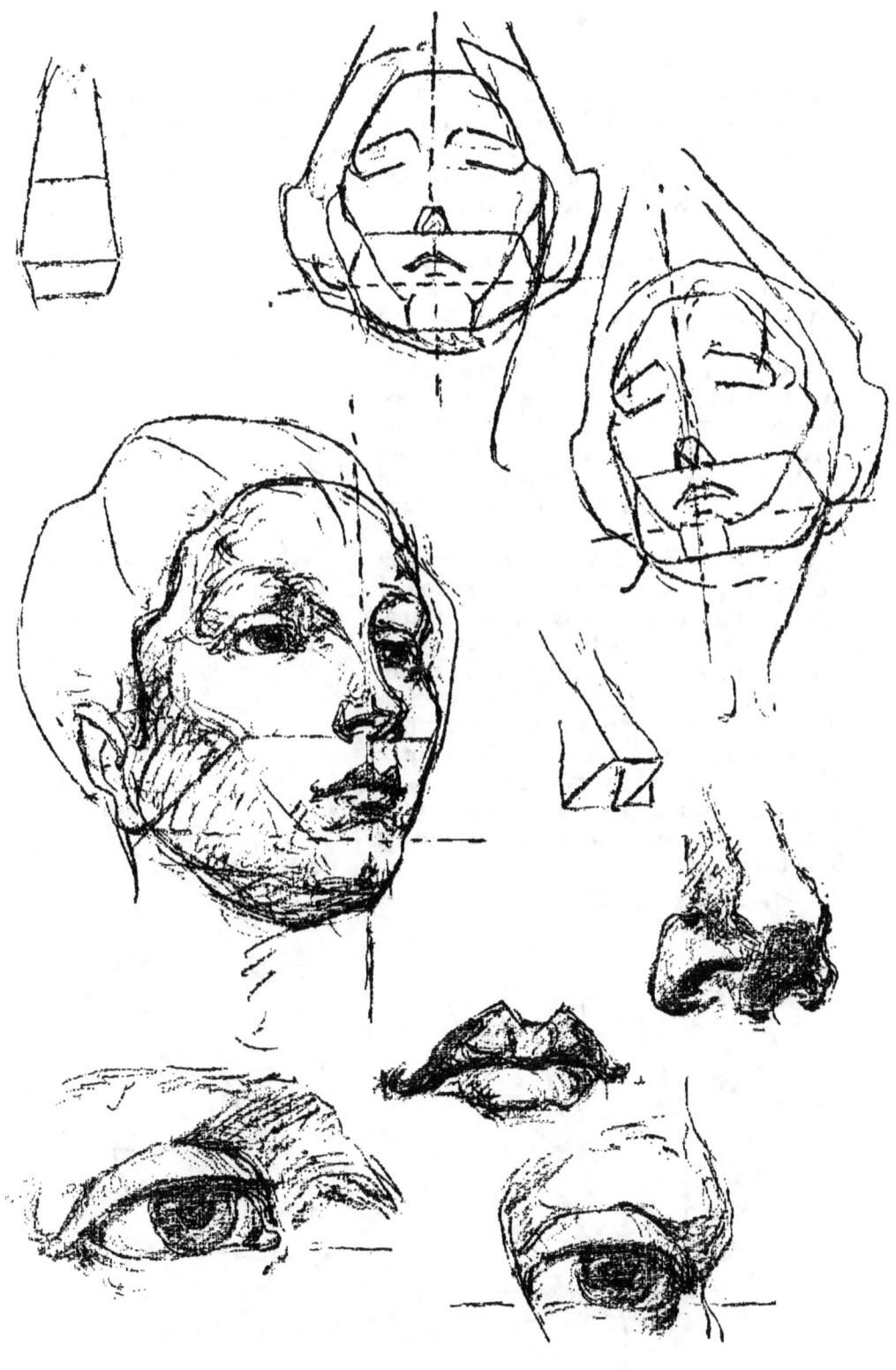

THE HEAD IN PROFILE
BELOW EYE LEVEL

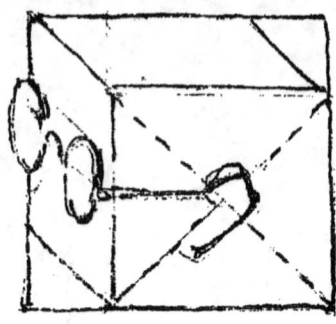

In looking down on an object you will see more or less the top of the object. If the object is a head, you will see the top of the head. The higher above the head you are, the more top you see, the lower you are, the less you see.

The top is nearest the level of the eye and the lower part further away. In profile at eye level the center of an adult's head would be a little below where the hook of a pair of spectacles curl around the top of the ears. If this line were continuous, it would pass through the eye, dividing the head into two parts. The base of the ear is on a level with the base of the nose. A line passing around the head from ear to ear would parallel the spectacles.

When the view is below eye level you are looking down and therefore see a portion of the top. That means the head, top, bottom and sides are rising to the level of the eye.

From the lower corners of the forehead, the cheek-bones mark the beginning of a plane descending downward in a long curve to the widest part of the chin. This curve marks the corner of the two great planes of the face, front and side. Here the spectacles turn in perspective as well as the line passing from ear to ear.

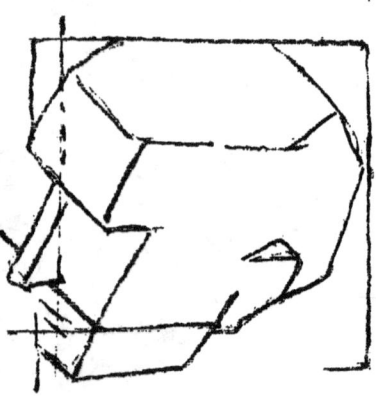

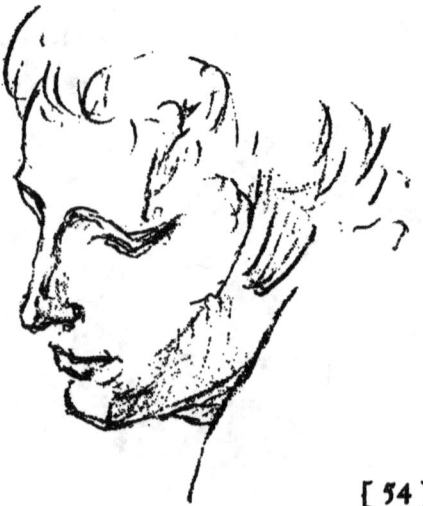

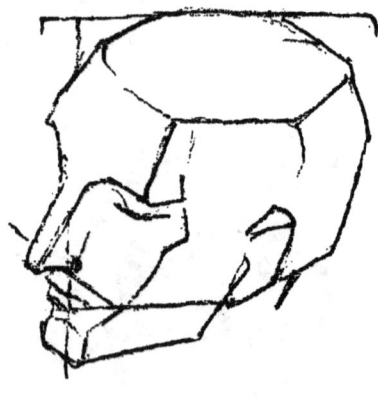

[54]

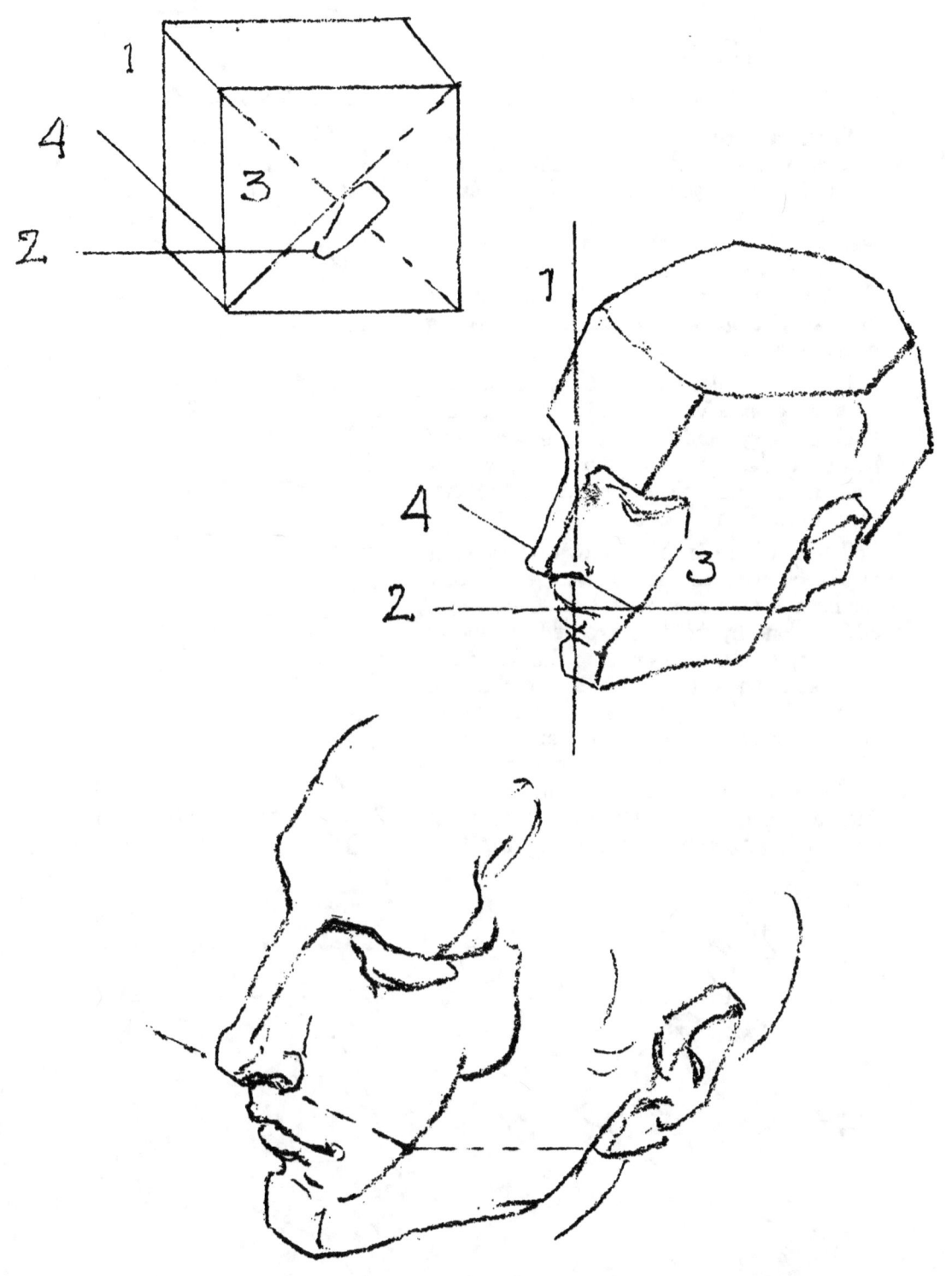

THE HEAD IN PROFILE
ABOVE EYE LEVEL

When a cube is tilted upward in such a way that the spectator is seeing it from beneath, it is above the horizon or height of the eye. If more of one side of the cube is seen than the other, the broader side will be less in perspective than the narrower side. The narrowest side of a cube presents the more acute angle and will have its vanishing point nearest.

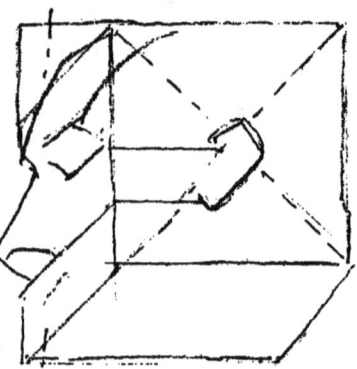

When an object is above eye level, the lines of perspective are coming down to the level of the eye and the vanishing points will be near or far apart according to the angles. The nearer the object the nearer together are the vanishing points.

When a head is to be drawn in profile it would be well to first determine whether the head is above or below eye level. This can be done by holding a pencil or rule at arms length at a right angle to the face from the base of the ear. If the base of the nose shows below the ruler, then you are looking up underneath the head, therefore the head is above eye level or tilted backward. If the head be three-quarters view or front, the line from ear to ear would cut below the nose as in profile when seen from beneath.

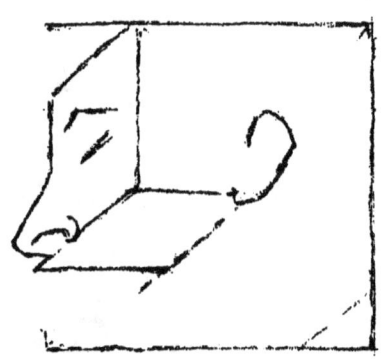

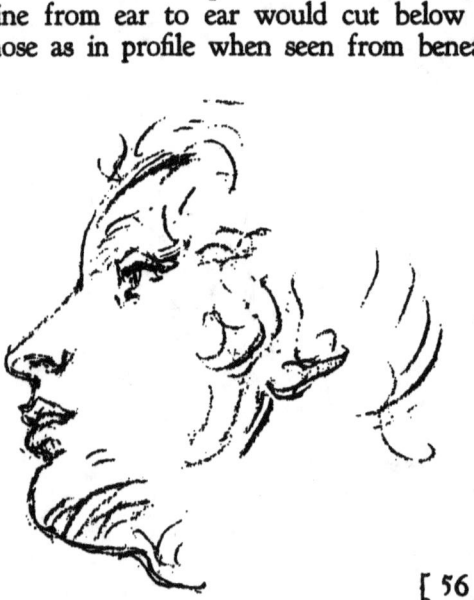

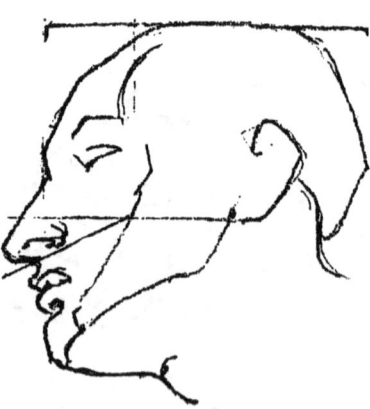

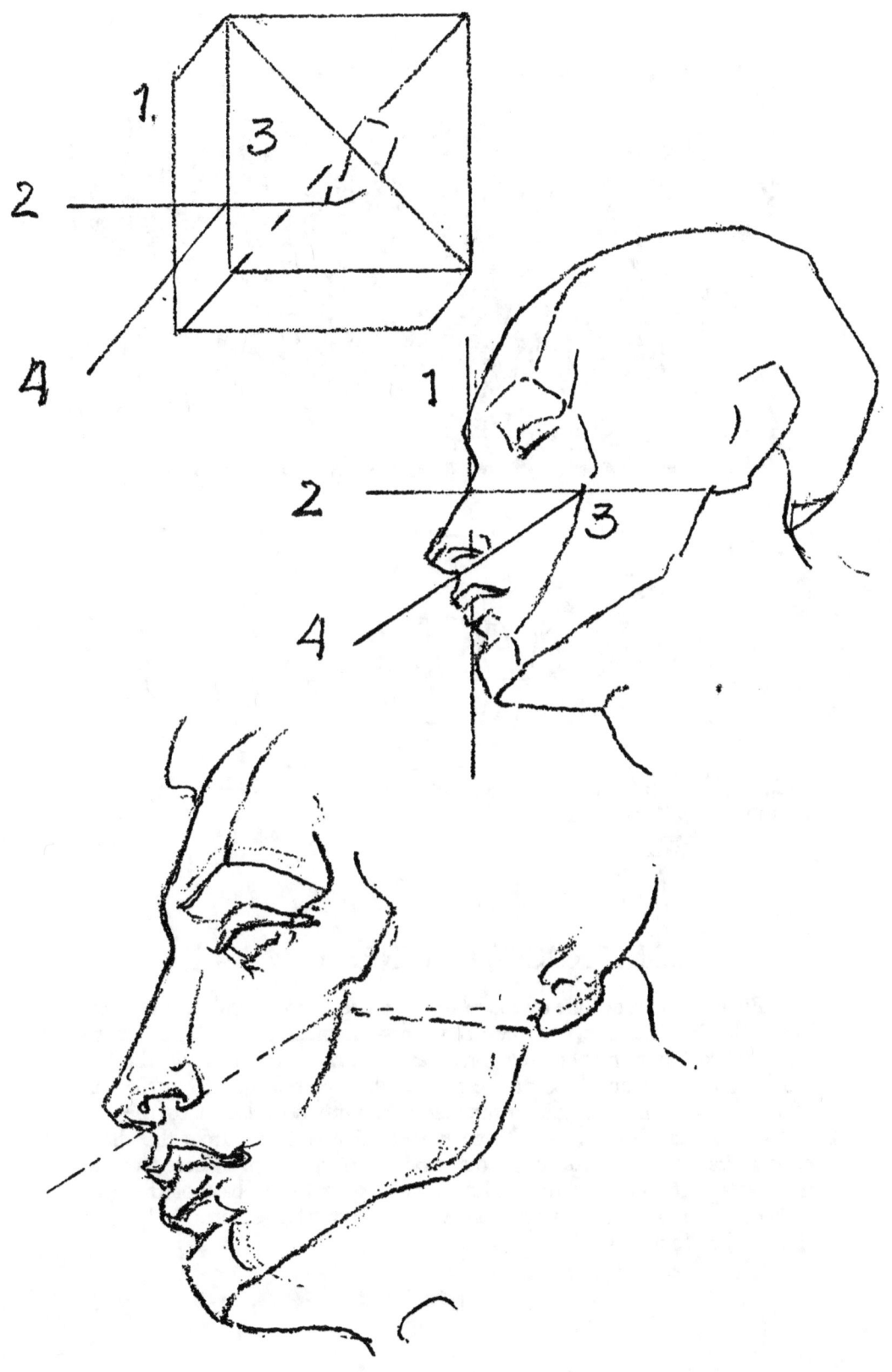

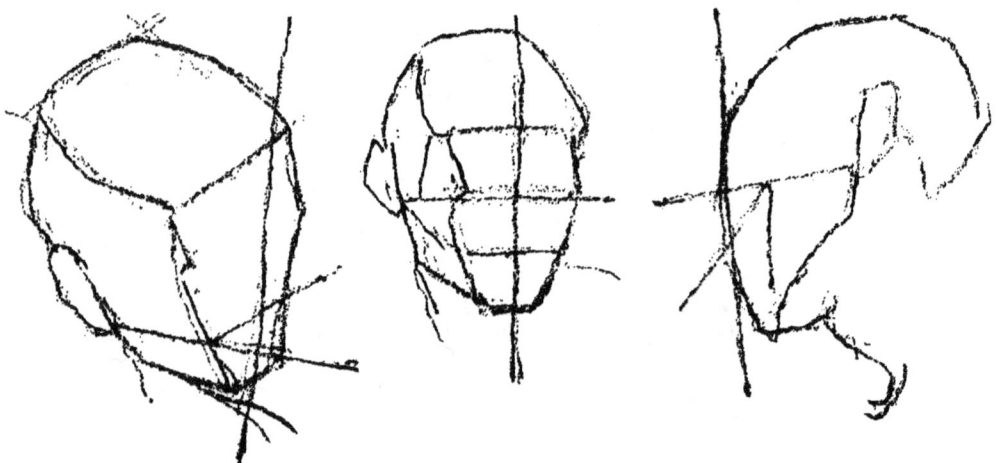

CONSTRUCTION LINES 1 - 2 - 3 - 4

First draw an outline of the head, then check up, it will take but four lines. Number one line is to be drawn first, number two line next, three and four to follow numerically. Number one line is drawn down the face touching the root and base of the nose. Number two line from the base of the ear at a right angle to number one, with no relation to the face as to where this line crosses. Number three line is drawn from the cheek-bone at its greatest width to the outer border of the chin. Where two and three intersect, start the fourth line and carry it to the base of the nose. Whether the head is seen from above or below, the features will follow the number four line.

[58]

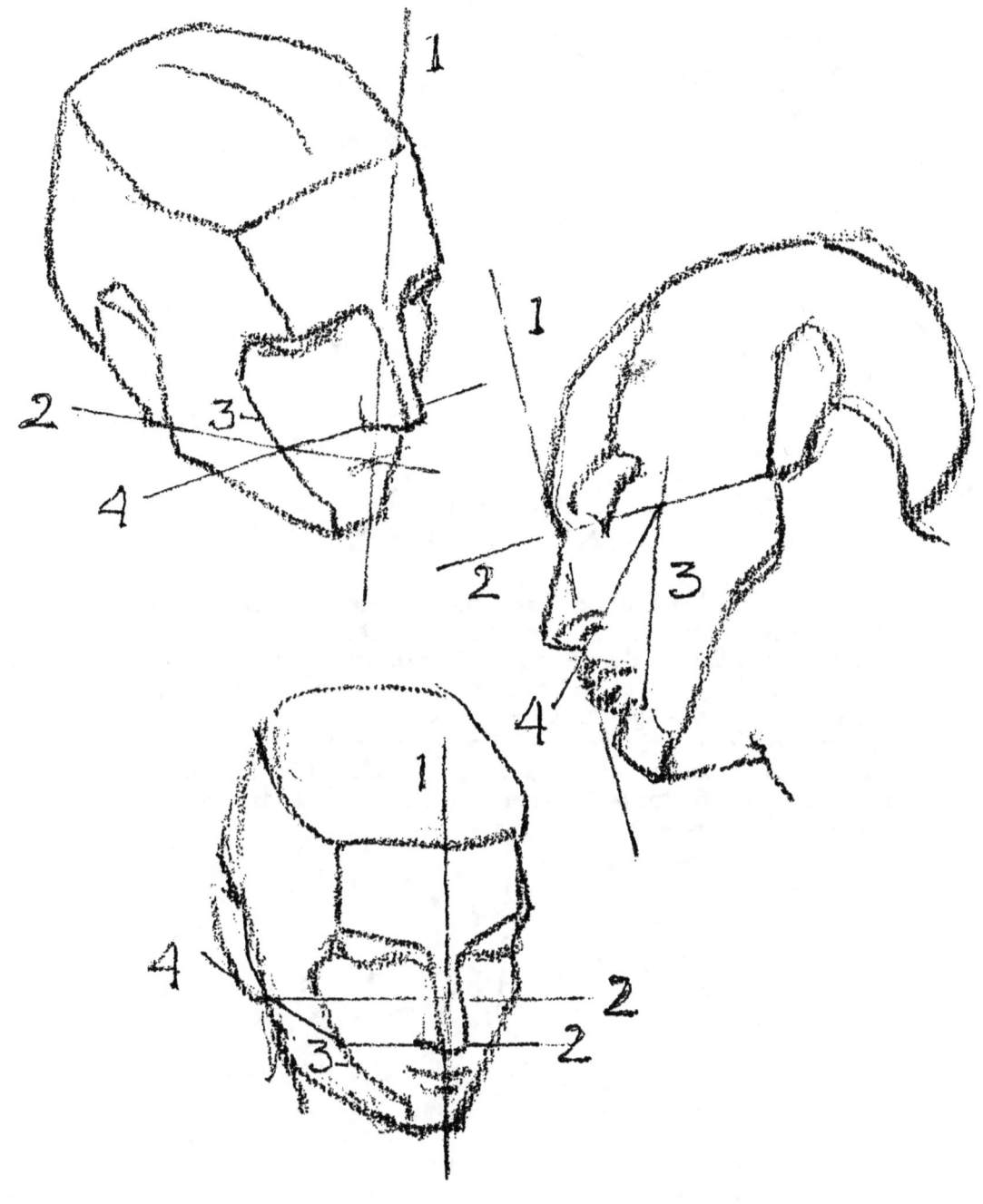

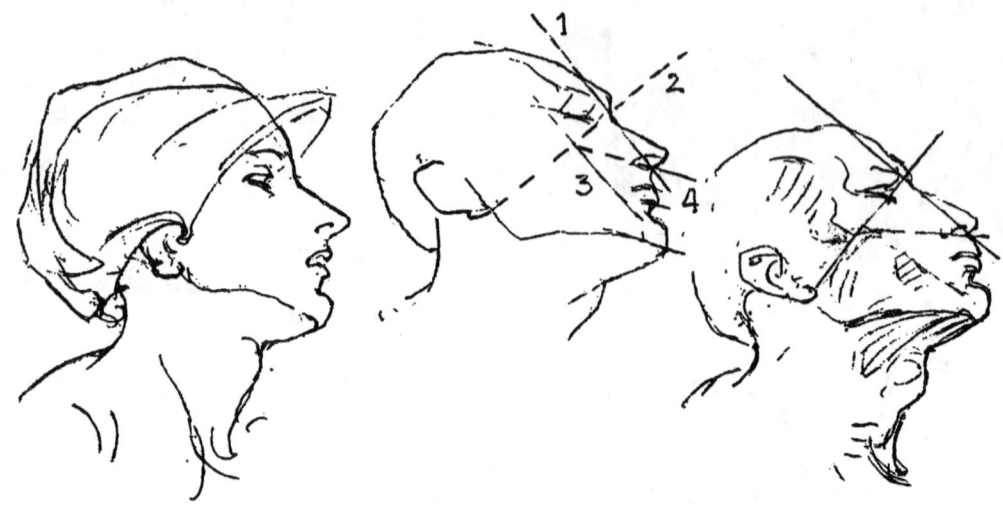

CUBE
CONSTRUCTION

When a head is built on a cube there is a sense of mass, a basis of measurement and comparison. The eye has a fixed point upon which to rest. A verticle line divides the head into two parts. These are equal, opposite, and balanced. Each side is an exact duplicate of the other. A horizontal line drawn through the lower eye lids divide the head in half. The lower portion again divided in the middle gives the base of the nose. The mouth is placed two-thirds up from the chin. Built on the form of a cube, the head has a sense of bulk and solidity that easily lends itself to foreshortening and perspective.

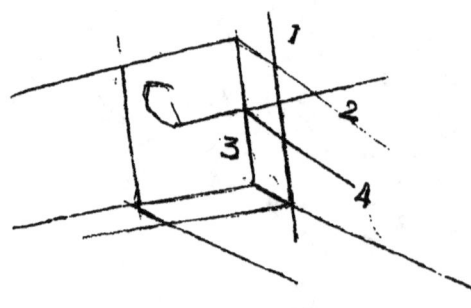

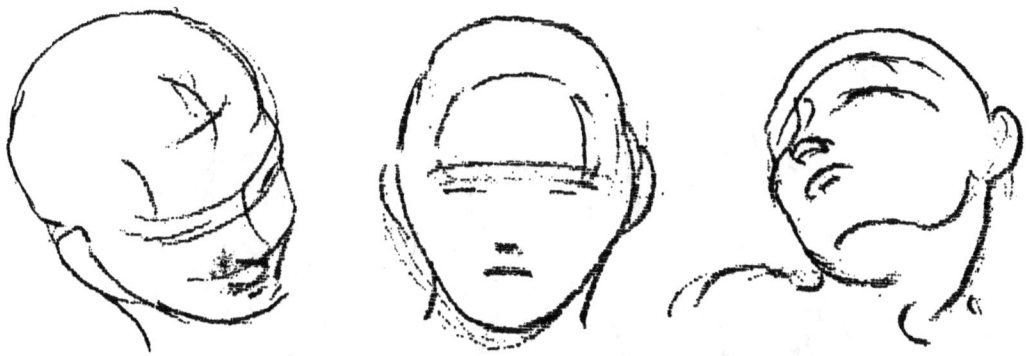

OVAL CONSTRUCTION

When heads are built on an oval, the basic idea is that the shape is rather like an egg. The main line passes through the features from top of head to chin. This is divided into three parts. The cranium and forehead of the adult occupy the top half, the lower half divided again in the middle gives the base of the nose. The mouth is placed two thirds the distance up from chin to nose. When the head is tilted or turned, the main axis that is drawn down the face, follows the oval. The divisions follow the divisions as before mentioned.

In the oval construction the eye and ear are taken as the medium line. Above this line is the top of the head, while below is the face.

A line drawn at a right angle to the line already drawn, gives another median or facial line. On this the features are marked off to give their relative positions. The carriage of the head rests upon its placing or poise upon the neck. When the head tips or leans forward, back or toward the sides, the head and neck must be in relation one to the other both in movement and rhythm.

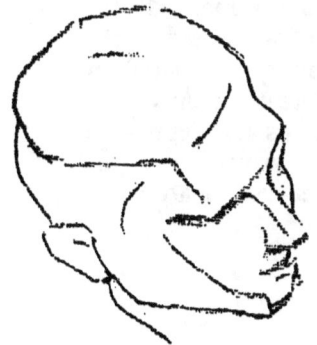 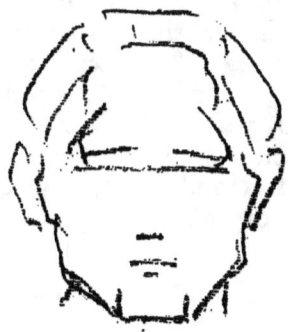 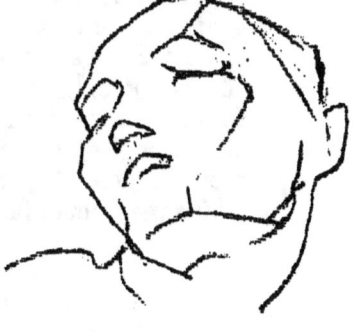

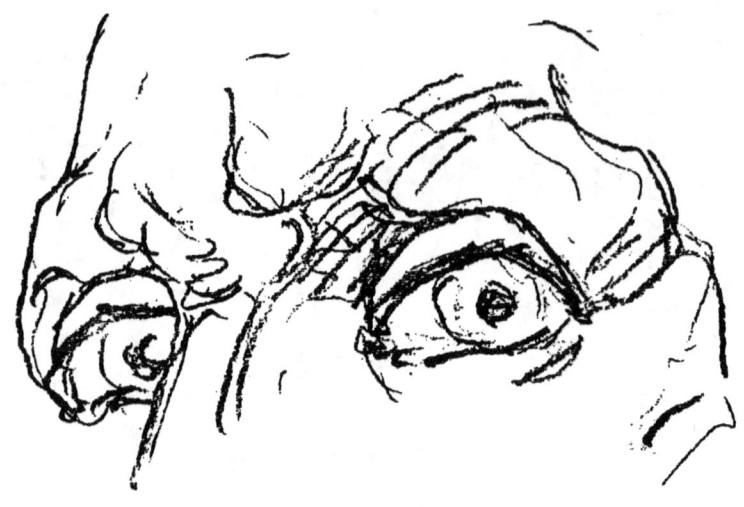

FEATURES - EXPRESSION

The variable expressions of the human face like the varied tones of the voice, seem sensed and ever changeable. Expression is not always caused by the contraction of certain muscles, but rather from the combined action of many muscles as well as the relaxation of their opposing muscles. The same group act, for example, in both the expression of smiling and laughter, in a lesser or greater degree. The eyes and mouth are surrounded by muscles of circular form. These muscles function primarily to close either mouth or eye. The filrous ring that surrounds the eye is attached to the inner angle of the orbit. The fibres of the outer rim blend or mingle with the bordering muscles of the face. Another muscle of circular form surrounds the mouth. The inner fibres operate on the lips, while the outer borders blend with the free ends of the surrounding facial muscles. The muscles which encircle the eye and mouth are operated by two distinct classes, those that control and those which oppose. If the mouth is stretched laterally and the muscles of the cheek are raised to the lower eyelid a smile is produced. By muscular action a paroxysm of laughter effects not only the face, but the body as well. The breath is drawn in, the chest, a diaphragm, is convulsed and agitated. The lips and depression of the angles of the mouth disclosing the teeth, the corrugation of the brows denote despair, fear and anger, rage and other combinations of which the human face is capable.

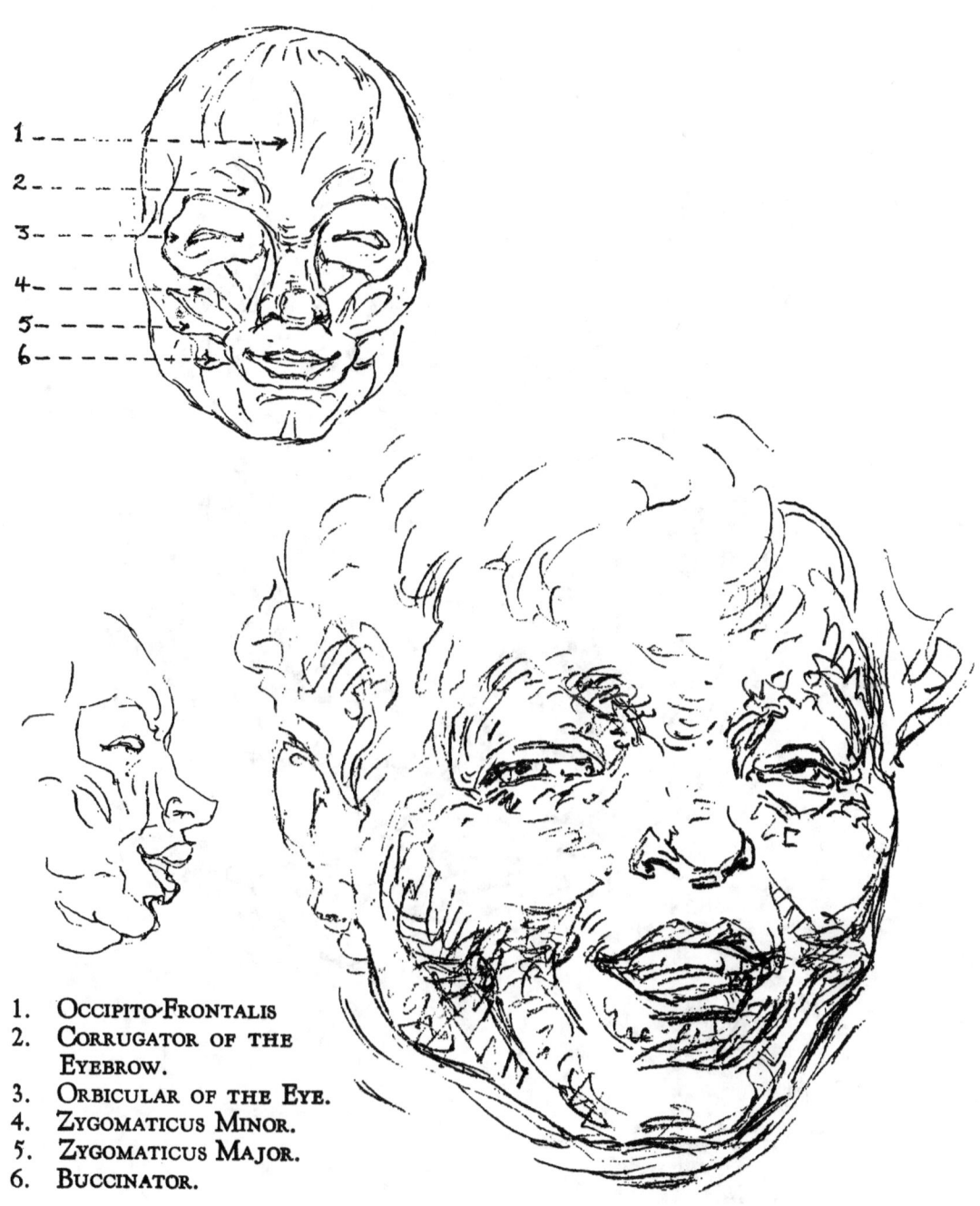

1. OCCIPITO-FRONTALIS
2. CORRUGATOR OF THE
 EYEBROW.
3. ORBICULAR OF THE EYE.
4. ZYGOMATICUS MINOR.
5. ZYGOMATICUS MAJOR.
6. BUCCINATOR.

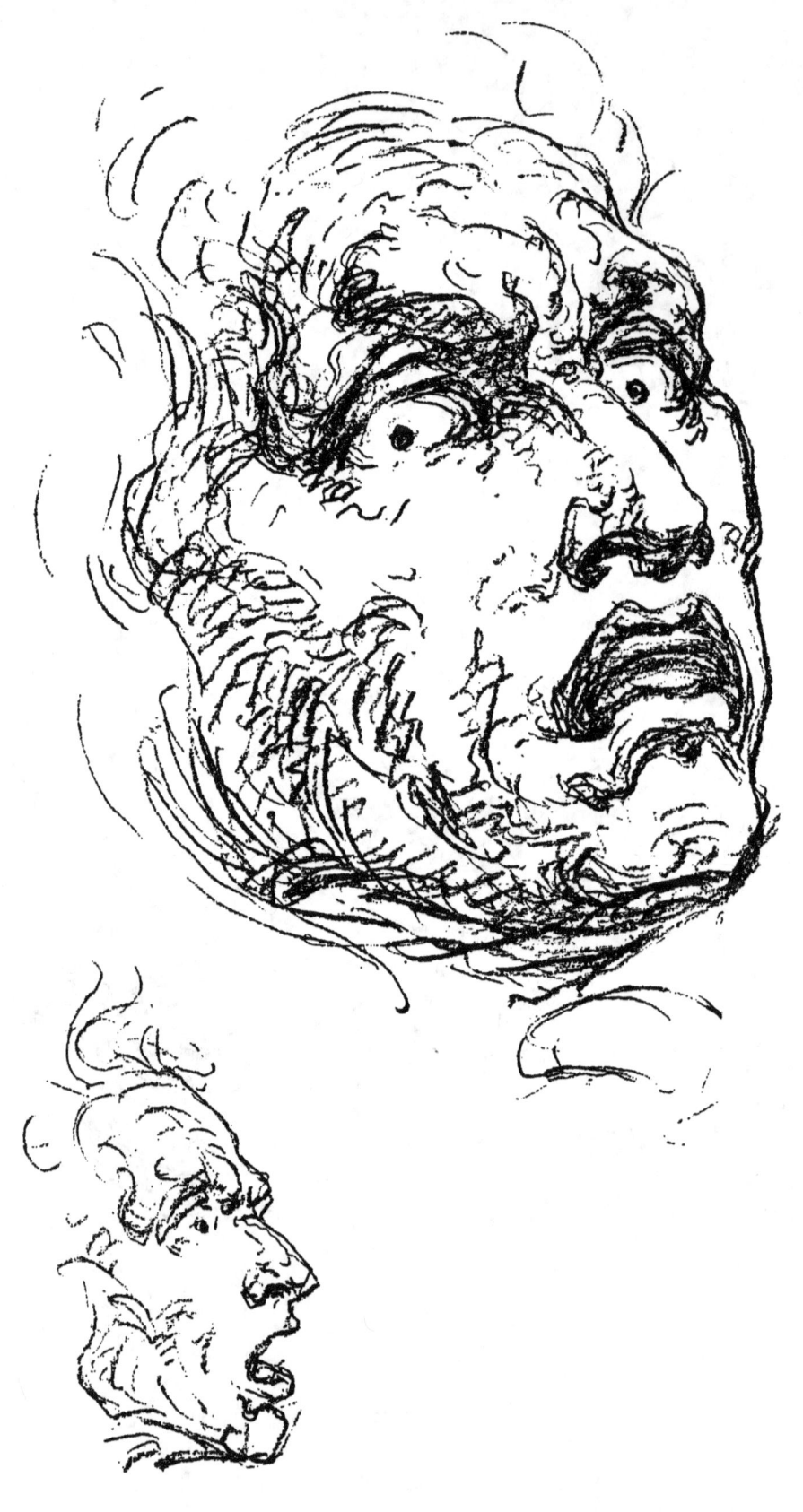